The FOCALGUIDE to Portraits

Günter Spitzing

Focal Press · London

Focal/Hastings House · New York

ISBN (excl. USA) 0 240 50758 4
ISBN (USA only) 0 8038 2354 1

Translated by Frank Dash
from PORTRÄTFOTOS—GEWUSST WIE

© Verlag Laterna magica
Joachim F. Richter, München, 1968

First edition 1974
Second impression 1974
Third impression 1975
Fourth impression 1976
Fifth impression 1977
Sixth impression 1979

Spanish edition "El Retrato",
Ediciones Omega, S.A., Barcelona.

Printed and bound at The Pitman Press, Bath

The
FOCALGUIDE
to
Portraits

THE ⓕ FOCALGUIDES TO

Contents

Introduction

This is a sort of cookery-book: a book that gives you detailed recipes, with all the necessary ingredients required to make photographic portraits that everybody will enjoy. Of course, some people are born with an eye for photography, while others find it a bit more difficult. But there is no one who could not take better pictures if he mastered all the ins and outs of the business.

I assume that you already have a camera or that you intend to buy one, but this book can also interest those who are not photographers. Nowadays we do not just look at a portrait occasionally, when we have time. We are constantly bombarded by people's pictures. They come in a steady stream from television, the cinema, from newpapers, books and magazines. But these politicians, artists, sportsmen, journalists and stars of all descriptions usually appear in their pictures as more important and more handsome, or else scruffier and uglier than they are in reality, and only on rare occasions do they appear as they really are.

Once we know the methods and all the tricks of the trade that we can use to put someone effectively into the picture, to make him or her more, or less, attractive, our eye becomes keener. We can look behind the facade and see the real person who makes an appearance on TV, on the cinema screen or in the picture papers. In fact everyone can be photographed to his or her advantage or disadvantage – by you as well as by anybody else.

A few days ago I took the trouble to sort out all my photos according to subjects. Surprisingly enough, in comparison with the rest of the mass of pictures, those showing people did not come out numerically on top. As a matter of fact I had expected that. On the other hand, those that affect me most are without any doubt photographs of people – and I am sure it is the same with you.

Portraits are not particularly difficult to make. Even the most technically inexperienced photographer can, with the help of the refinements built into quite a moderately priced modern cam-

era, circumnavigate the once terrifying rocks of photographic technique. On the other hand, it goes without saying that no camera is entirely self-operating. No camera can control the composition of the picture, from the effectiveness of the section included, the most suitable camera position and favourable background, to the correct lighting. It may be that you are afraid of difficulties in any particular one of these details. But all these problems of picture composition can be solved by following the rules that are outlined in the following pages.

Taking
the First
Steps

I take it that you are not one of those people who rashly declare on seeing every dud picture: "My camera's no good, it was too cheap". In ninety-nine cases out of a hundred it is not the fault of the camera when a photograph comes out badly. Of course it may occasionally happen that a camera goes on strike. And certainly you may find one kind of camera easier to handle than another. Cameras with built-in exposure meters are particularly handy to use. Reflex cameras give you a big picture in the viewfinder. You may prefer a simple camera with automatic facilities or one that leaves all the decisions to you.

The expensive, and perhaps complex camera generally has first class lenses enabling you to make negatives and transparencies which give colossal enlargements on a projection screen or on paper. Very simple cameras, on the other hand, give you pictures that should not be blown up beyond postcard size.

For the effectiveness of the photograph, however, give or take a slight difference in sharpness – it is not a question of a better or not so good camera. You can get attractive pictures from any camera. It is merely a matter of knowing how. Moreover, as portraits do not require extreme sharpness, they can be considered, from a strictly photo-technical standpoint, as particularly simple subjects. And just because very sharply defined detail is relatively unimportant in pictures of people, film of high sensitivity can be used without hesitation.

Using fast films

There is a limitation, however, on the use of very fast (highly sensitive) films. If you use a standard lens (ie. not a long focus type, see page 176) you may need to enlarge only part of the image. The consequent high degree of enlargement may cause some graininess in the picture to become evident. This can occasionally be intentional, but it can also frequently be very disagreeable.

Fundamentally, nearly every film – with the exception of specialized material for technical and scientific purposes – is suitable for taking pictures of people. The fast and very fast kinds, however, give softer results. This means that they diminish contrast in the subject – and that is exactly what we most desire in portraits. For

my part, for snapshot portraits I prefer fast films. As for the most suitable types of colour and black-and-white film for use in special cases, these will be considered in relation to each individual case.

Types of portrait

The word "portrait" came to us from the French, who took it from Latin. Scholars, who know these things, say that it came from *protrahere,* to draw out. Later, the word took on the meaning of "to bring into the light", for everything that is produced from the darkness ends up somehow or other in the light. To get a photograph we must also bring the object into suitable light. The word came into the English language, of course, long before the invention of photography. Portraits can still be made today with a pencil, a paint brush, chalk, with a knife, or hammer and chisel. A special kind of portrait – the death-mask – is a cast made with plaster of paris.

However, nowadays most portraits, and especially the most convincing ones, owe their existence to the camera. I say this quite deliberately, though I realize I am sticking my neck out and shall be violently attacked from one side or the other. But who can honestly say that when he needs a lifelike portrait of himself for any particular purpose he thinks of anything else than a photograph? The operative word is "lifelike". A portrait in the strict meaning of the word must have this quality, irrespective of its origin. True, Mr X may look more important in his photograph, Mrs Y more beautiful and Miss Z less prepossessing than she is in reality; all the same, the photograph must make it possible to recognize that it really is Mr X, Mrs Y or Miss Z we are looking at. The job of a person's likeness to approximate to reality was in fact exactly performed by an antiquated fashion, referred to now only as a joke, of "counterfeit", another word from the French *contrefait,* or copied. So a portrait has, as it were, to copy the person it represents. A passport photo, therefore, however horrible it may be, is by definition a portrait. Whether the photo of a pin-up or covergirl on the outside of an illustrated magazine can be classed as a portrait is a matter for acrimonious argument. The

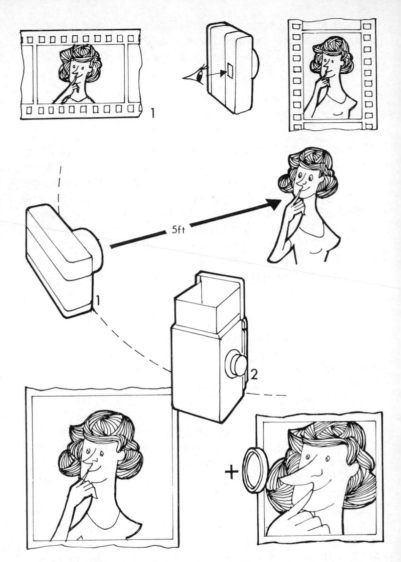

First principles. 1, At 5ft. you can obtain a head and shoulders shot with a simple 35 mm camera. It is best to turn the camera to take an upright picture. 2. At 5ft. your picture is generally free from distortion. To go closer, you have to add a close-up lens, but you then risk some distortion of prominent features. 3. The eye-level

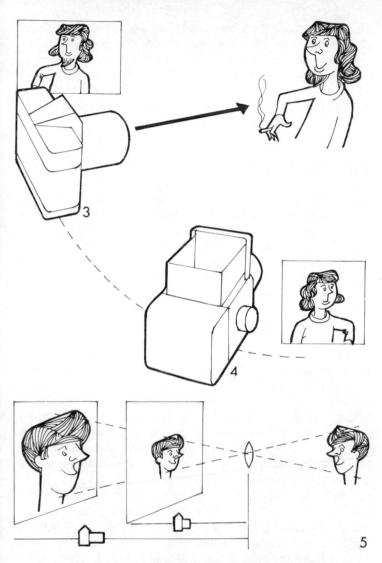

SLR presents an accurate correctly oriented image of the subject.
4. The waist-level reflex shows an image reversed left-to-right. 5.
The more sophisticated camera has interchangeable lenses that
enable you to obtain a larger image. Providing the shooting distance
is unchanged, perspective remains the same.

interest here lies less in the individual, non-transferable facial features of the girl as in the charms of her shapely person. The face could be exchanged for any other face without worrying anyone. Sometimes the faces have been so arranged that they are indistinguishable from others. Now I will not prudishly confine myself to genuine portraits. Even borderline subjects such as pin-ups will at least get a passing reference.

Emphasizing the face

A human being's personality is stamped most clearly on the face. For this reason, in any picture claiming to be a portrait, the face must be clearly visible and recognizable – the whole face, that is. If we only take in the eyes, or the mouth, or only the tip of the nose, in my opinion there is not enough there to enable anyone to see with whom they are concerned. Everything from the mouth to the eyebrows should be there. In some cases possibly, the mouth might be hidden, but that represents the extreme limit in any photograph that has the slightest pretension to be a portrait.

Certainly, in my experience, the danger of taking too little of a person to make too big a picture is negligible. It is much more common to see too much of a person – naturally shown too small in the photo. Of course it is quite possible to take a photograph of the whole person. This shows someone from the top of his head to the soles of his feet in his or her full size and beauty. But most pictures of this kind show too much of the surroundings. In cases where this results in showing the microscopic face of a tiny human figure in the middle of a vast landscape, the viewer can only guess the person's identity.

Admittedly a standing person gives the picture an unfortunate, lanky look. However, if the photographer goes up close enough to make the head come almost to the top of the picture with the feet almost at the lower edge, the face can be seen clearly enough. But if the person is sitting or kneeling or squatting, the camera can get somewhat nearer and thereby get a bigger picture. To make the image really big and clear, the picture must be cut down a bit, and, as many people will think that the photographer has made a mistake if the head is missing, it is better to

cut off the superfluous portion from the bottom of the picture. Professional photographers are fond of cutting off the part below the knees in order to get a better picture of the upper part of the body. This is them known as a *three-quarter length picture*. The head and shoulder picture, on the other hand, can show just that or everything above the waist.

What the finder shows

The image shown by a single-lens reflex camera takes in pretty well what you will find later in the picture. As a safety precaution the finder image includes fractionally less than will appear on the film. We have to recognize the usefulness of this provision, because the transparency frames and enlarger negative carriers do mask a little bit of the picture. The situation is rather different in the case of cameras equipped with the usual, widely used telescopic finders, and also in twin-lens-reflex cameras. As the finder is placed slightly over or to one side of the lens, the view it frames is not identical with the final picture that is formed in the camera. This divergence, technically known by the rather splendid name of "parallax", is the bigger and more troublesome the nearer the model is to the camera. With a distance of 13 ft (4 m) or more, parallax has a merely theoretical importance. But in the 2 m or 2.5 to 4 m range the difference between the finder image and the picture projected by the lens is somewhat compensated for by the fact that rather more appears in the photo than in the finder. At distances of less than six or seven feet (2 m) however, parallax error becomes unpleasantly noticeable. And this is precisely the important distance for portrait photographs.

In passing, I should like to emphasize that portraiture with a long-focus lens from a greater distance has considerable advantages for several reasons, including the one under discussion.

When using the ordinary square shape, with the finder immediately above the lens, we must raise the camera a little in order to cancel out parallax to some extent. If the whole picture frame is to be filled by a head, we must "scrape" the chin with the bottom of the finder and leave a little space above the head. In this way we are certain not to slice off the top of a person's scalp.

When, as is usually the case, the picture is upright and the finder to the right of the lens, we have to pare the model slightly on the left and therefore visualize a small extra strip on the right-hand side. If the finder is on the left, we take in a little bit more of the subject on the left-hand side.

After all, we are not anxious to chop off the back of our victim's head, or, even worse, the tip of his nose.

One word of warning. Many finders are placed over the lens and slightly to one side. In this case we have to raise the camera a little and turn it a degree or so to left or right. Fortunately most see-through finders are fitted with parallax lines. These show what will be missing from the picture at a distance, say, of 5 ft (1.5 m) or less.

A few years ago I used for a short time a curious camera whose finder simply twisted of its own accord. I first saw some of the pictures at Christmas, and every time I saw them they had a little surprise for me. But all these troubles have been removed by the camera I now possess. The light frame in the finder shifts in conjunction with the focusing, so that it always shows the correct image area. A contrivance of this kind is known as automatic parallax compensation.

Changes in style and fashion

Before we get down to practical details, I should like to touch on a theme to which we shall return again and again in the pages of this book: What does the expression, "the modern portrait" signify exactly?

In looking at older photographic portraits it is easy to see when they were made. This is due partly to fashions and – with women – to make-up. As recently as the first half of the 60s, in every magazine, pictures of ladies with heavily made-up lips were the order of the day. Today you can glance through magazines, photographic year-books and journals and see that the mouth is now discreetly made up, whereas the eyes are boldly emphasized.

But it is not only fashions and make-up that have been subject to constant change. Photographers themselves are carried away by the flood of ever-changing fashion. There used to be a fashion,

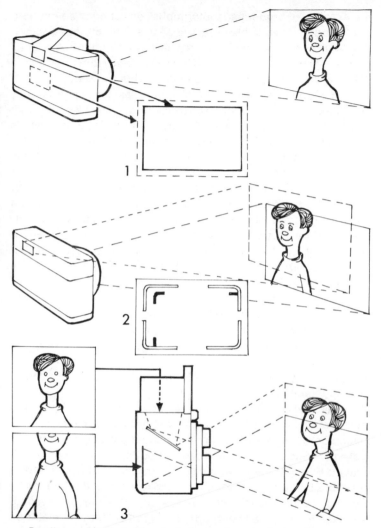

Parallax problems. 1. The single lens reflex viewfinder shows you the exact image that is projected on the film, with a slight safety margin. 2. The camera with a separate viewfinder system suffers from parallax effects, which become noticeable at close range. Correction marks therefore appear in the viewfinder. 3. The twin-lens reflex is also prone to parallax error at close range because the viewing lens is above the taking lens.

for example of producing photographs consisting of a light half-profile printed by double exposure on to a dark full-face against-the-light view. Today such pictures have almost literally vanished from the face of photography. If they do appear from time to time they have a strong whiff of the antique about them.

But I maintain that behind the changing fashions, and entirely uninfluenced by their ephemeral passage, one can discern something that might be termed photographic style. Even style is not unchangeable, but its step is lighter, more cautious; it advances inaudibly on tiptoe amidst the staccato din of fashions engaged in a tug-of-war with one another.

Our forebears wanted to record the changeless, dogged dignity of man. That was their style. Whoever had his photograph taken before World War I and to some extent after it, dominates the situation – in his portrait, at least. I – and, I maintain – my whole generation with me, have nothing in common with this attitude. Our ancestors, our grandfathers, perhaps even our fathers, were complacent and satisfied with their universally accepted worthiness. Any superficial splashing of the waves that reached them from the surge of feeling left them unmoved.

But when I grab my camera, I want to catch the spontaneous expression of a face, an expression that was not there before the click of the shutter and will not be there after it. I capture fractions of seconds. And when I am photographed I prefer to see myself in a spontaneous attitude.

It may be that our successors will again lay stress on dignity and composure. In the history of man there has always been an alternation between love of the immediate and a predilection for repose in timelessness. Another way of putting it would be to say that the baroque alternates with the classical. See how the sculptures in a baroque castle or church make limbs and draperies fly through the air. The sculptor has seized the fraction of a second, anticipating a typically photographic representational method. The baroque was inevitably followed by a classical period. It is no contradiction if today in a whole row of portraits earnest faces look steadfastly to the front. The smile, which not so long ago was a must for nearly all portraits, may be seen as the first attempt to temper the stern dignity of pre-World War I with some faint suggestion of feeling. It has now virtually vanished from faces. The

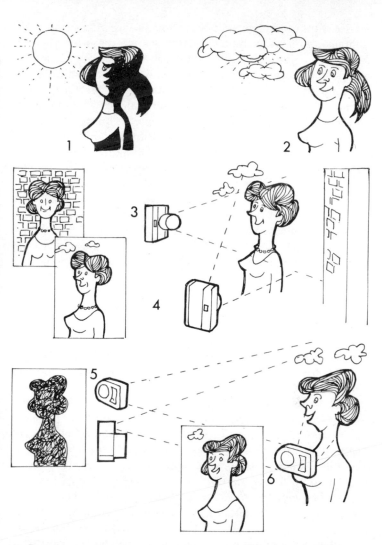

Basic errors can ruin your first attempts: 1. Strong sunlight casts heavy shadows. 2. Clouds over the sun soften the contrast. 3. Viewpoint influences background. A brick wall is not attractive. 4. Change the viewpoint and use the sky or other simpler background. 5. Hold the exposure meter so that a great deal of sky is included and you get underexposure. 6. Take a close-up reading and the exposure is right.

face in a photograph is no longer expected to radiate courteous affability, but must compel attention. Hence the preference for big, serious eyes looking straight at you from the photograph. In composing these outwardly peaceful pictures, that show no excitement, the photographer has in most cases carefully spaced out light and dark or coloured lines and surfaces. This makes the pictures extremely decorative. The subject, a human being, has been transformed by the photograph into a kind of ornament.

Art photographers who work for illustrated and fashion magazines go even further. On the one hand they organize their models decoratively and at the same time try to put a bit of life into them. They painstakingly build up artificial spontaneity. Twisted limbs, half-open mouths (as if the lady had inflamed tonsils) are supposed to simulate real life and, above all, arouse interest. So we have the absurd situation that the pattern for photographs artistically created in large studios is the very pattern of the natural, genuine, living snapshot.

Making the first attempt

For your first attempt at portraiture, you should preferably use a black-and-white film, take along as a model somebody you know well, and avoid the sun. For portraiture, we definitely do not need the sun, but we badly need cloud cover – as thick as possible. But what if we have the bad luck to have a succession of pitilessly sunny summer or winter days? What if no friendly cloud shows itself? Well, then we simply take the photo in the shade.

The diffused light in shadow or under a covering of cloud is soft and flattering to the features. They come out clearly, because there is no place for unwelcome black shadows. I will not exaggerate this point. I readily admit that you can of course make good portraits in bright sunshine. But in that case you must know something about lighting technique. We shall be coming to that point a little later on. Experience has shown that under cloudy skies nearly all portraits come out well, almost without our help, whereas out and out sunny-weather pictures are only rarely satisfactory.

The question of background presents no great difficulty. We need

not take too long searching for the most attractive surface. For a start, we can use a simple light area such as the white or blue sky. There is one major problem to be solved. Strangely enough, a thing that gives many people a great deal of trouble is the correct distance between the camera and the subject. Two start with, choose a distance of about 5 ft. or 1.5 metres. Do not go closer to your model, but do not go farther away either. In this way you will get approximately a head and shoulders picture. It goes without saying that you will hold the camera for an upright picture – unless your camera takes square pictures.

For the moment there is not much to be said about lighting. I take it that you know how to use a fully automatic camera or can use an exposure meter.

If possible, take your model, at least for your first attempts, in semi-profile, that is, with the head turned slightly to left or right and the eyes looking straight ahead, past the camera. That is a fairly conventional portrait, possibly marred by the typical photograph-face which the "victim" immediately puts on. There are several ways of making him relax this peculiar, tense expression. This is what I do when necessary. As I press the shutter-release, the model's face invariably loses its tension. Then I wind the film on as quickly as possible and press the release again. The second photo will almost certainly show a relaxed expression. There is something spontaneous about it, which is just what we endeavour to get in our photos. Nobody expects a second shot to follow so quickly after the first.

Some Slightly
Technical
Aspects

Mr . . . never mind his name . . . puts his hand into the inside pocket of his jacket, extracts a wallet, opens it carefully and takes out an envelope. This in turn conceals a few snaps. I am asked to admire them – not so much the pictures, that is, but what they represent. A smashing creature, he insists, pretty and ladylike at the same time, the sort of girl a man likes to be seen about with.

He gives me a detailed description of the charms of his beloved, and he has every reason for doing so, for the photo itself reveals practically nothing of this beauty he so much admires. In the photograph the no doubt charming lady is too small for any details to be distinguished.

Shoot from the right distance

Just watch people on holiday as they pull out their cameras. Many of them try to get a person on to their film from a distance of nearly 50 ft or 15 metres. Very few of them are daring enough to go up closer than about 15 ft or 5 m. Is it any wonder that someone who is asked to look at the photograph has to listen to a load of rubbish before he can recognize any resemblance between the picture and the original?

Why do people who cannot be said to suffer normally from an excess of modesty hesitate to go up close to the object of their adoration just because they have a camera in their hands? If the beauty of a face, the intelligence revealed in the features and, last but not least, the lively expression are to be recognizable, the distance between camera and model must not be greater than about 8 ft or 2.50 m. Always provided, of course, that you are using a normal camera with a normal lens. A long-focus lens (see page 176) allows for considerably greater distances between the camera and the subject. It is also assumed that the picture is not to be enlarged to any great extent. Pictures which are to be blown up to the size of the pages in this book, or more, can be taken from rather longer distances.

Unfortunately many photos, especially those taken by high-quality lenses, are not enlarged enough, for my taste. It is only in the larger sizes, say 10 × 12 in or 18 × 24 cm that pictures really begin to be effective. What is more, this size is not terribly ex-

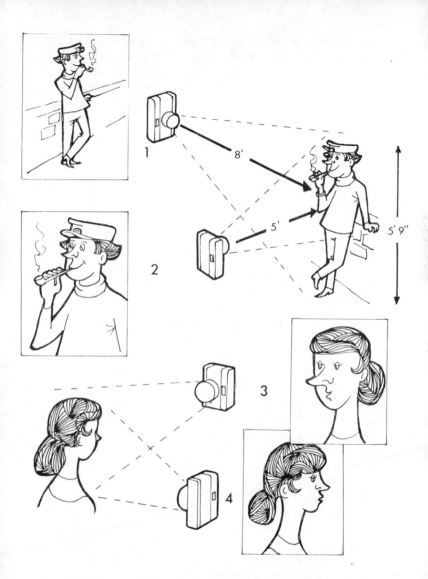

Fill the frame. 1. If you shoot from about 8ft. on 35 mm film with a 50 mm lens an average sized man just about fills the frame. 2. For a head and shoulders shot, 5ft. is about right. 3. If you shoot full face at less than 5ft. you risk distortion. 4. It is better to change the viewpoint to avoid features projecting toward the camera.

pensive. You may object that with an expensive miniature camera anyone can produce masterpieces of enlargement, but even if you have an inexpensive camera you can make enlargements of postcard size at least. I assure you that, compared with the usual enprints, they are well worth the additional cost.

How to fill the frame

You can get a good general idea of how much of the subject you will get on the film from any given distance, with the help of two simple rules of thumb:

1. Horizontally: the area of the subject taken in is just half the distance between subject and camera.
2. Vertically: the area included is three-quarters of the distance between subject and camera.

Both rules apply to the usual 35 mm camera standard lens of 50 mm focal length. A survey of the usual picture measurements for other sizes and lenses is given in the Appendix.

Thus, with the camera at 2.50 m or 8 ft, a man 1.75 m or about 5 ft 9 in could be comfortably accommodated within the picture area. At 1.50 m or about 5 ft the standard lens of most cameras takes in an area of 105 by 70 cm. (3 ft 6 in by 2 ft 4 in). Into this a head and shoulders view fits nicely, with "space to breathe". This technique of fitting the subject comfortably into the picture area is known as "filling the frame" but note that 1.5 m is the closest advisable approach for the standard portrait. What happens if we want the face alone to fill the whole picture? For normal effects, I certainly do not advise you to go closer to an adult than about one metre, which is quite possible with most cameras. There would be trouble with perspective distortion. As every schoolboy knows, our eye, like the eye of the camera, sees things smaller the farther away they are from us.

If we take a picture of a crocodile from close to his front, a position that enables us to admire his beautiful teeth, the head will be very big and the tail, being farther away, will be relatively small. But the question of whether we take the charming scaly creature

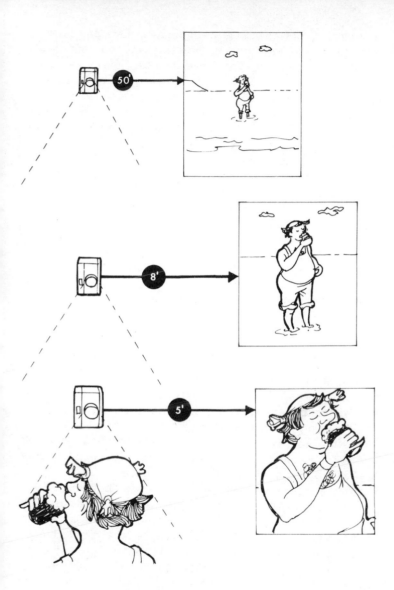

Get in close. If you shoot from 50ft. the figure is lost in the surroundings. At 8ft. the figure dominates the picture. Go right in to 5ft. and you concentrate all interest on the subject.

from close up or far away has its importance. From the close-up, we get an exaggerated impression of the tapering from head to tail. Pictures taken from a greater distance are not subject to this false perspective. Similarly, portraits taken from a reasonable distance look natural. Those taken too close tend to caricature. It is basically true to say that the caricatural tendency of a portrait becomes more marked the farther the photographer departs from the rule of keeping 5 ft away from the face.

This rule depends on an old photographic precept, which says that there is no distortion of perspective if the distance between subject and camera is 10 times as great as the depth of the object photographed. The average distance between the tip of a person's nose and his ears is about 15 cm (6 in). Hence the tenfold distance of 1.50 m or 5 ft. Naturally, you do not follow this rule slavishly. With strongly characteristic faces, a near view can be favourable, because the powerfully characterized features come out all the more clearly. The near approach is particularly dangerous with classically beautiful features. But you will soon accumulate your own stock of experience and will then be able to judge for yourself when to observe the ancient precept and when you may or must kick over the traces.

Profile portraits can be regarded as exceptions. With the camera pointed at one ear, the depth from ear to nose, which is the greatest depth we are concerned with, is considerably smaller. Take my own head as an example: This distance is just 10 cm. So you could take my profile head from as close as 1 m. Even half-profiles offer more favourable proportions, thus enabling you to come up closer and get the head quite large in your picture, even though it does not fill all the available space.

Portraits are generally made in upright format, but a head taken from a distance of 1 m with a standard lens would suit a horizontal shape. As the portion from neck to hair nicely fill the paper from top to bottom, the portrait fills the space better and looks bigger. In this case you should place the head to left or right of the picture. In the empty part of the photo arrange if possible to include a bit of distant landscape or other appropriate background not too sharply focused.

In children, the nose to ear distance is smaller than with adults. You can quite safely photograph a six-year-old from 1 m. In any

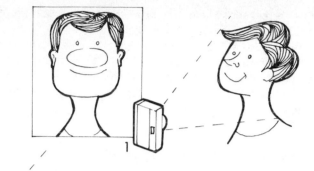

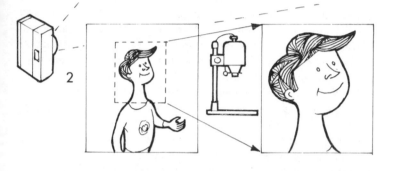

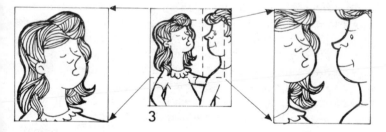

Avoiding distortion. 1. The close-up view can cause distortion. 2. If you want a large head but have only a standard lens, shoot from farther away and enlarge a portion of the image. 3. Selective enlargement can produce several pictures from one negative.

case, a test shot will tell you how far, or rather, how near you can approach in each particular case.

There is also a little trick for getting a feminine head, taken from directly in front, as big as possible in the picture: long hair can be combed and so arranged that the distance from nose-tip to hair does not exceed 10 cm in depth – an elegant method of getting round the 1.50 m limit.

Allowing for selective enlargement

When a close approach to fill the frame would be likely to produce undesirable effects, you have to shoot from farther away and subsequently enlarge only part of the image. If by any chance you do not make your own enlargements, your photographic dealer will readily make an attractive selective enlargement from your own negative. It costs rather more than an enlargement of the whole area but is often well worth the additional expense.

It is not possible to make colour enlargements of sections from transparencies by direct processing. If you are anxious to obtain, say, a head section from a head and shoulders picture, you must order a double-size enlargement and cut out from it the bit you want. But to obtain a 13 × 18 enlargement instead of a 9 × 12 picture will cost you more than double the price. For all that, this procedure is an advantage financially only if you want a single picture. If you want several prints the roundabout way with an intermediate negative is definitely preferable. In principle, section enlargements on transparency material are feasible both from negative film or colour transparencies.

One more point: take black-and-white or colour pictures which are subsequently to be enlarged excessively with the least exposure possible Over-exposure tends to emphasise the grain effect of a photograph. For a head only or part of a face a somewhat longer focal length lens is an advantage. Unfortunately, not every camera can be equipped with long-focus lenses. Worse still, many long-focus lenses do not allow a close enough approach to the model. These "long lenses" – for 35 mm cameras, with a focal length between 85 and 135 – are only useful for portraits when the camera can be used at a distance of 1.50 m, but many

Informal portraits are often more satisfactory than those taken in surroundings and circumstances unfamiliar to the sitter—*Andrew Righthouse*, Harrow School of Photography.

Opposite: Mother might not be enthusiastic about such a shot, but there is little doubt about its liveliness and impact—*John Thornton*.

Page 33: Even indoors, the use of window lighting with some diffusion makes a carefully posed shot look relaxed and informal—*Leslie Turtle*.

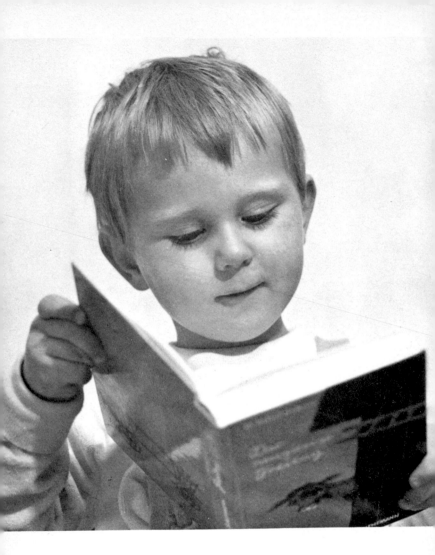

Get the child interested in a book or a game and wait for the right moment to take a flash photograph without disturbing him. A single flashbulb and a slow film made this shot.

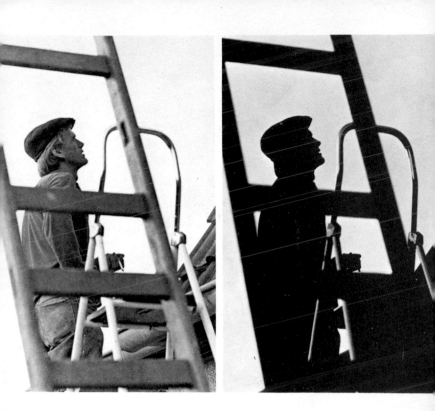

The profile exposure against a white, cloud-covered sky gives a grey figure against a light background. Prolonged printing exposure on extra-hard paper produces a silhouette against a deeper-toned sky.

Right: The lines of age have their own appeal while the use of the Spanish fisherman's cigarette lighter adds a touch of documentary interest—*I Rosenberg,* Harrow School of Photography.

Below: Careful cropping has placed the two faces at the point of maximum interest —*Olaf Kurbjeweit.*

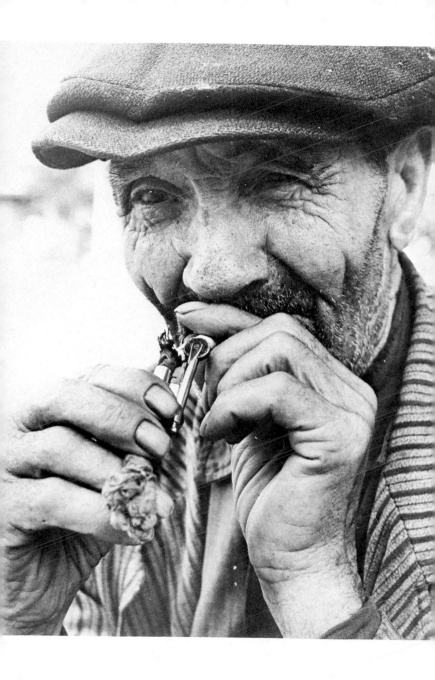

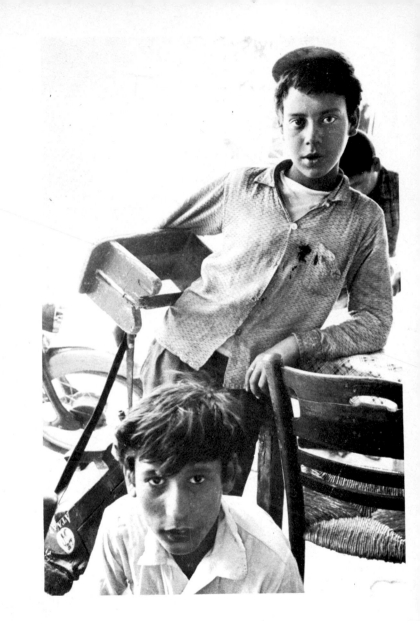

Two shoe-shine boys in Athens. While one was polishing the photographer's shoes, he grabbed a quick shot with a 35mm camera.

such lenses have distances scale ending at 2.50 m, or perhaps 4 m on a 135 mm lens. To overcome that, get your optician to fit a simple supplementary lens of 0.5 diopters. This is not expensive when you consider the greater scope it gives you. With a scale-setting of 6 m the supplementary lens allows you to go up to within 149 cm of your model, whatever the focal length of your lens. If your camera is not a reflex and has no built-in focusing, you will do well, of course, to use a supplementary detachable rangefinder.

A decision as to the actual part of the image to be used in the final picture can be made at the same time as the exposure. With slides, you generally have to use the whole image because masking down for projection is not practicable. Otherwise, various sections of a negative can be selected during the process of enlargement and, by masking and/or turning the enlarging frame you can produce an almost unbelievable variety of pictures. The head and shoulders picture of a man may appear somewhat stiff and formal if the body faces squarely to the front, but if we turn the frame so that the body-axis lies along the diagonal and the model seems to bend his head forwards, the portrait suddenly becomes friendly.

If the figure leans backwards it radiates peace, superiority and tranquil pride (the armchair effect). We cannot of course turn the picture in this way if there are straight lines in the background which indicate the top and bottom of the picture.

The section chosen for enlargement is important. In a profile or half-profile portrait quite a large part of the back of the person's head can be trimmed away. The other side should rarely be so closely trimmed. A basic rule is that some free space should be left in the direction of the glance, because otherwise the picture appears cramped. Similarly, unwanted features of a face can be toned down or suppressed entirely by the choice of a high or low camera position, or else by enlarging only a carefully selected portion of the image.

A bulging, bulbous forehead or an over-long lower portion of the face may not be disturbing in daily life, especially as the weak spots can be disguised to some extent by a clever hair-do. But in a photograph it looks altogether too prominent. By skilful trimming of a profile portrait, we can snip away the offending portion

either from the forehead at the top of the picture or from the chin below.

Then of course we have the possibility of hiding some unwanted detail behind a screen of some kind. We have our model looking out of a window, for example. The top of his forehead can be masked by the top of the window frame. Part of the cross-bar can be made use of to make a misshapen ear disappear from a half-profile portrait.

Let us assume that a lady who has an over-sharp chin has to sit for a head and shoulders portrait. What can be done about it? Simple: she holds her chin in her hands so as to conceal its imperfections.

There is no need for me to supply you with a whole catalogue of all the objects that can be used to amend faces in photographs. I need only draw your attention to leaves, grasses, branches and flowers. You have only to put the plants so much in the foreground that they come out as hazy and indistinct. This image stands out most pleasingly against a sharply focused face in the background. And in addition you can paint out anything in the foreground or background that does not suit your purpose.

Sharpness, soft focus and blur

Portraits do not demand particularly crisp definition. This is undoubtedly an advantage in that the photographer need not worry about extreme precision. A lack of sharpness, which would be disagreeable in an architectural subject, for example, would in some circumstances be quite acceptable in a portrait. This means in practice that:

1 Portraits can be taken even with simple cameras.
2 Portraits can tolerate relatively big enlargement.
3 In case of need, portraits can be made with ultra-rapid films.

We have also the very agreeable facility that portraits, unlike other subjects, have a fixed point on which we can focus for sharpness, namely the eyes. For half-profiles this sharp focus point lies normally on the eye nearer the camera. You can make use of this

procedure even if you are working with a stop of 2.8, 2, or even 1.4. The cheeks, ears and nose will then be a little out of focus – and it doesn't matter at all. Occasionally this haziness can be used quite deliberately to tone down over-large pores in the skin. If on the other hand a large head which fills the picture has to have not only sharp eyes, but sharp ears and a sharp tip of the nose as well, this can be quite safely ensured by using a stop of 5.6 As a matter of interest it may be mentioned that the modern trend is again towards lack of sharpness in the whole face, including the eyes.

There used to be a fashion for what were known as "soft-focus lenses" or "soft-focus supplementary discs". These optical soft-effect gadgets had the effect of spreading the lighter parts of the picture into the darker areas. The result was rather that obtained when you simply make an error in focusing. Whatever the soft-focus fans may say to the contrary, pictures taken through these funny disc affairs are just like out-of-focus photographs. Nevertheless there was undoubtedly a real purpose underlying the use of soft-focus devices. The merest wrinkle, the smallest pore or the faintest skin blemish on a feminine face of classic beauty, which we indulgently fail to notice in reality, is pitilessly revealed by the eagle eye of the camera. The soft focus attachment tended to cover such blemishes or render them less noticeable.

It was not feasible before the first years of the 20th century to obtain pictures by using sharp-focus lenses with a large aperture. Only then was it possible to get fautless sharpness over the whole picture. No wonder that from that moment everybody from the amateur photographer to the professional film-maker plumped for sharp definition. Wrinkles and skin blemishes were simply obliterated by retouching.

One day, however, the public got sick of everlasting sharpness. The hour of the soft-focus lens had come. People no longer wanted to see things as they were, but preferred to see them hidden in haze – with good reason in the 20s and 30s.

In 1923 Walter Zilly campaigned in a photographic journal for soft-focus pictures. In the course of an article, symbolically illustrated by a picture entitled "The Veil", he wrote: "... But some quietly renounced the strict orthodoxy of sharp definition, and led the way from realism to expressionism. The exaggerated

sharpness of the photographs was too clear, too astringent to leave any room for the viewer's fantasy. When one looks at pictures made with a soft-focus lens, one must admit that they are far more artistic and impressive than the sharply-defined pictures of yesterday . . .''

The cinema especially used the soft-focus lens in order to present a generally approving public with mature matrons minus their wrinkles and swathed in a mist of youthful bloom. After the war, however, people had had enough of illusion, and especially of its results. The dreamy haze of soft-focus was considered to be as false as it was cheap. The Italians created a new film realism. No longer was a pretty face the aim, but character in the expression. Freckles and wrinkles blossomed in all their glory in close-up on the cinema screen.

In photography the snapshot attempted, not always successfully, to grab slices of real life.

Responsible photographers strove to represent humanity as they believed it really was. But the everlasting imitators who cheerfully paddle in every new wave of fashion, painted men as even more dreary than they really were. The urge for sharpness was encouraged, not only by the spirit of the age, but by a purely technical consideration. The day of flash photography had dawned. One could now make irreproachable pictures in poor light conditions. This facility had to be exploited to the full.

As the post-war years began to put on fat, some people began gradually to grow sick of exaggerated sharpness. The pendulum swung in the other direction. Nowadays, misty confusion counts as the summit of daring – which does not mean that the sharply realistic picture has had its day. While in the 20s people talked of the ''expressionism'' of a hazy picture, today one sometimes hears the same phenomenon described as ''impressionist''. In reality the question boils down to a sort of new romanticism. In many sections of society people are weary of illusion-killing realism and are looking round for new ideas, thanks to which they evidently hope to make harsh reality into something more pleasant to behold. But this does not mean that we have come back to soft-focus devices.

Nowadays models are deliberately softened by the following methods:

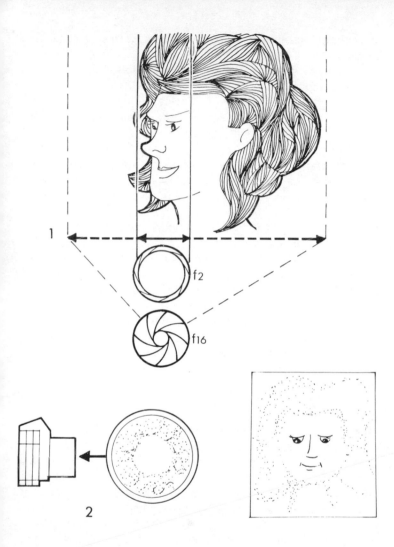

1. Shooting at a large aperture can restrict the plane of sharp focus, leaving the rest of the subject more or less vague according to the aperture used. 2. A similar effect can be obtained by smearing petroleum jelly around the edges of a haze filter held well away from the lens. Close to the lens, it produces an all-over soft-focus effect.

1 Unsharp focusing, either by means of a wide stop or by long focus.

2 Blurring by movement. A subject in motion is taken with an overlong exposure.

3 Moving the camera, which is quickly swung or turned.

4 Exaggerating grain. Exposures on ultra-rapid film are over-enlarged.

So photographic style swings in course of time backwards and forwards between unsharp and needle-sharp. It is like women's fashions. Suddenly the hemline rises to above the knees; but no sooner have we feasted our eyes on more or less beautiful legs than the skirts reach down to the ankles. Exciting display and at times even more exciting concealment play hide-and-seek. My own opinion is that a tiny fraction of a photograph should be absolutely sharp, even if all the rest is hazy. We need some fixed point for our eye and this, as we have already agreed, should be the eye of our model. Even if you want to keep the whole face hazy to the point of its being unrecognizable, you should in all circumstances try to get some important feature sharply defined. This might be an outstretched hand, a blossom growing on a twig that dances in front of the sitter, or perhaps some detail of the musical instrument he is playing. (Nor should you reject out of hand the idea of a person in a characteristic pose, shown unsharp against a well-defined background).

Moreover, I occasionally take unsharp head portraits for purely pictorial reasons. I am not concerned with embellishing the complexion. The removal of furrows and wrinkles I consider to be a job for the professional photographers. They generally use large-size cameras in order to get big negatives. From these, any unwanted blemishes such as wrinkles, pimples or red blotches can easily be removed by retouching. But the professional photographer has to provide portraits for publicity purposes and so on.

It is therefore quite sensible to work over the photos in question with paint-brush and scraping-knife. The press photographer on the one hand, and the amateur who does photography for the sheer joy of it, has no need to impress personnel officers with his pictures.

Here it is rather a case on the one hand of getting effective photos, possibly with the aid of soft-focus methods. On the other hand it is a question of discovering with a camera the characteristic features of a face. And for this the picture must have sufficient definition. So any unwanted details on the surface are not to be eliminated by retouching but toned down by certain photographic tricks. (We will deal with these individually later on.)

The importance of skin-tone

In order that the face, the most important thing in a portrait, should be given its full photographic value, neither the greys nor the colours in which it is reproduced should – except in the hands – be repeated in any large or important area of the photograph. The features must stand out boldly both in brightness and colour scale. I realize of course that in snapshots this ideal is not always attainable. In such picutres it is not so much a question of form as of liveliness. But posed photographs and "stage-managed" snapshots are in fact more effective if you succeed in keeping a single individual tone for skin colour. Even an average face can be captivating, fascinating and attractive if its grey tone or colour is either the lightest or the darkest shade in the photograph. I am speaking of course only of greys which occupy relatively large areas. Even when the face is the largest dark area in the picture it is almost impossible to prevent the eyebrows from being even darker. This, however, is no more disturbing to the general impression than is the white of the eyes, which is even lighter than the colour of the skin, and which anyway represents the brightest of bright areas in the photo. Here I insert a note in parenthesis for readers who make their own enlargements: when you are settling the question of exposure and grade of paper by test strips, see that the portrait paper is placed in such a position under the enlarger that the eye comes into the picture. You then know that you have not given too long an exposure if the white of the eye remains really white.

There are various ways of calculating the grey tones of a face. When using flash or photofloods, for example, you can regulate the lighting of foreground and background one by the other.

Filters and skin-tones

In colour photography the rendering of skin-tones is less of a problem than with black-and-white photographs. Skin blemishes do not appear so clearly, especially if the exposures are made by warm morning or late afternoon sun, or when a light, pink correcting filter is used.

In black-and-white photographs, red spots and pimples are apt to show up clearly. They can however be suppressed, or at least toned down by an orange filter. A red filter erases them more drastically, but warm-coloured filters, beginning with yellow, have the drawback of taking the colour out of the skin. In South America it was common practice to use a red filter to lighten swarthy complexions. Nowadays, when only a few oldfashioned people judge a man's character and intelligence by the colour of his skin, photographers endeavour on the contrary to give a faithful rendering of the African's bronze or ebony skin-tones.

Even holidaymakers who tan their skin in the summer or winter sun are most unwilling to have it bleached. In fact they want their photo to show them even browner than they are. This can best be achieved by the use of a green filter. Both green and blue filters are much used for photography by artificial light. This helps to offset the characteristic incandescent light effect. Photographic lamps – as also the sun when it is low on the horizon – have somewhat the same effect as an orange filter would have. Apart from lightening the skin and eradicating red spots, they also make red lips look extremely pale. This can be avoided by the use of a bluish lipstick. Anyway, the modern fashion is for very pale lips. Blue eyes taken through an orange filter come out decidedly dark.

The filters cannot, however, operate only on pimples or skin-tan. You have to take account of their effect on other parts of the picture. If you are afraid that a light green pullover might have the same tone of grey as the face, you can do two jobs at once by lightening the complexion and darkening the pullover with an orange filter. If we are photographing a dark-tanned face we can darken it by using a green filter. In this case the pullover would be light. The little filter table on page 167 tells you which filters to use in order to obtain in your picture various colours in distinguishable tone values. A panchromatic film used without a fil-

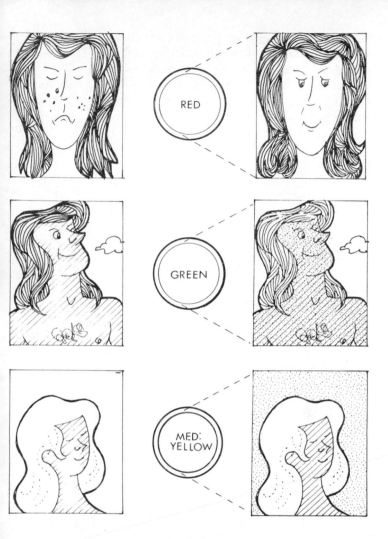

Filters can have drastic effects on skin tones. 1. A red filter removes pimples and blemishes but also shows pale lips. 2. A green filter emphasises sun tan, freckles, etc. 3. Yellow darkens a sky background but may take a little colour out of the skin.

ter transposes the colours into greys which correspond more or less to what we see with our eyes. Individual black-and-white films differ somewhat in their interpretation of colours. Fast films are especially prone to show red in exaggeratedly light tones. They also tend in daylight, if used with an orange filter, to drain the colour from skin and lips.

Exposure for skin-tones

If you are the proud possessor of an automatic camera I must congratulate you. You have few problems with exposure. If, however, you prefer a camera with manual control of diaphragm aperture and shutter speed you are again to be congratulated. As a compensation for righteousness you are in a position to calculate the exposure with great accuracy. (But you enjoy the same advantage if the automatic exposure meter of your apparatus can be modified or cut out by choice.)

Let us assume you have a separate exposure meter. Whenever possible you should take the so-called close-up reading with it. That is, you gauge your model's face from a distance of about 10–15 in (20 to 30 cm). But be careful to see that your hand holding the exposure meter does not shade the area you are measuring. If you cannot, or will not, or must not go up so close, make a substitute measurement of your own hand. You should in any case do this also when the complexion is markedly different from skin-tones in our latitudes. If I had measured, say, the faces of Africans or crisply browned girls by direct means, my pictures would have been hopelessly overexposed. The lovely dark skin-tone would have been changed into a pale grey.

Different kinds of film must of course be treated somewhat differently. Transparencies must be precisely exposed for European bad-weather complexions. With very poor light – in bad weather, for example – the diaphragm may be opened one degree wider. However, even if your camera is loaded with negative film (black-and-white or colour), you can expose "by the skin". If necessary these films can tolerate over-exposure of one or two stops. This applies especially when the model has black hair or black clothes and when these have to be well defined. In this case we

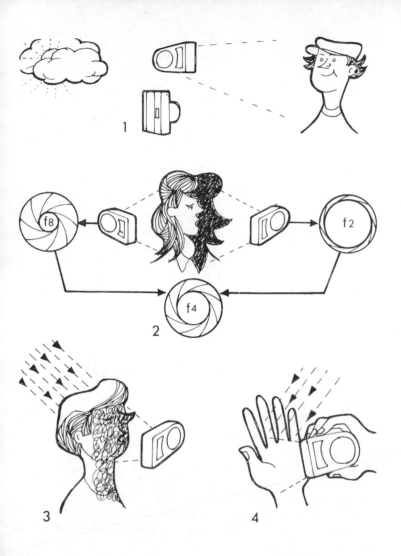

Exposure techniques. 1. A straight reading from reasonably close to the subject gives correct exposure in overcast conditions. 2. In strong sunlight, take the mean average of highlight and shadow readings. 3. In backlighting take a close-up reading. 4. When it is difficult to take a reading directly from the subject, use your hand as a substitute.

have to decide whether it is enough, for example, for dark hair to be shown simply as a black mass relieved by a few highlights, or whether every single hair has to be visible.

Photographers of the old school insist on showing every small detail in a picture. They will have nothing to do with undefined areas of light and shade. I myself, together with many others who have a predilection for graphical forms, am no great definition-fanatic.

Because overexposure produces graininess, it is unwise to use ultrarapid black-and-white film. High-key photos must be made with at least two supplementary degrees of light. These are those interesting hard enlargements (on extra-hard paper) which show the mouth, the nostrils, hair and especially of course the eyes in black or grey, but without any intermediate grey tones. The skin becomes one completely white area.

With fully automatic cameras an overexposure of one or two stops is obtained by setting the film speed to a lower figure.

Choosing a suitable background

The besetting sin in portraiture – that is excessive distance from the model – is almost equalled by the weakness of an unsuitable background.

It is easy to understand why things occasionally go wrong: the photographer is so intent on his main object that he fails to think of anything else at the moment of taking the picture. But in the photograph every small defect is distressingly obvious. For a variety of reasons, discussion of which would take us too far afield, the camera's eye sees things more clearly and in greater detail than does the human eye. That is why I consider it to be useful at this point to talk about the background before we come to grips with the main issue.

When do backgrounds become troublesome? Briefly, when they are intrusive. I have seen portraits in which a poor chap has a telegraph pole growing out of his head. The photographer had stood his victim straight in front of the thing. In another picture – I have it in front of me as I write – the branch of a beech-tree has grown out of the unfortunate boy's left ear. In the real sit-

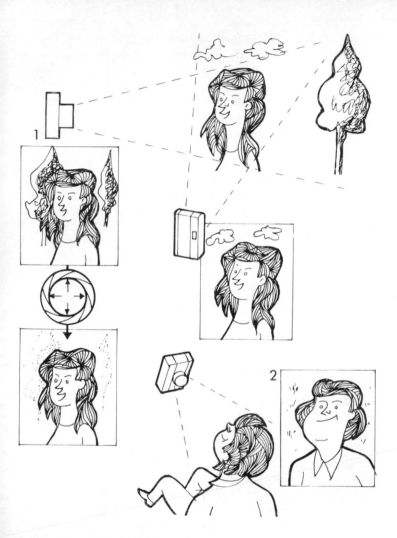

Choosing the background. 1. From your chosen viewpoint, you may find that the background is distracting. You can shoot at a wide aperture to throw the background out of focus or change the viewpoint to provide a better background. 2. Shooting downwards to use the lawn as a background.

uation, of course, the objects in front of the camera are spaced out in depth. The branch was some way behind the boy's head. This would be evident in a stereoscopic picture, but normal photography compresses everything that is sharply defined into one plane. This explains why so many pictures come out quite differently from what we had expected.

Avoid these gremlins by applying the golden rule: when making a portrait place your model as far away from the background as possible.

I am aware that in 99.9 per cent of portraits the head is immediately in front of a wall, a bush, a hedge or stuck against something or other. It seems that many models desperately need something to lean against. But there really is no point in offering them back support. Leave as much space as possible between the person and the background. The latter should be out of focus. The more it is, the better will the foreground stand out.

This leads me to my second plea: give the shortest possible exposure, so that you can use a correspondingly large stop. With a wide aperture the distant background will be hazy, fluid – an almost unified monochrome area. I realize of course that this rule cannot always be followed literally in practice. For snapshot portraits you may require for safety a certain reserve depth of field. But apart from this, what are you to do when you are using an automatic camera which has a fixed exposure time or no focusing facility. In this case you should place a light-absorbing filter in front of the lens, a grey or polarizing filter, for example, and use a film of a relatively low speed. These enable you to use a larger stop. If for one reason or another it is absolutely impossible to make a background of houses, trees and so on sufficiently hazy, there is nothing else for it than to look out for some naturally monotone background.

A faintly-suggested landscape round a portrait is attractive – more charming in fact than any featureless background, but a simpler surface which is certain to give a satisfactory result is fortunately to be found virtually everywhere and at any time. When in doubt, use the sky as your background. Your model can stand on higher ground or you can kneel down and let the blue or cloudy area of the sky afford a suitably light and unobtrusive background.

You can also go about it the opposite way: you yourself get on to a low wall and look for something like a grey road surface or a golden beach which can act as a background. You may perhaps be making your portrait on a sunny day in a spot behind which there is a wide shady area. In that case your model will stand out light and clear against a dark background.

I must say something here about long-focus lenses, which tend to render the background considerably less sharp. This facilitates snapshot technique, because you need not pay so much attention to the question. Of course, one very neat way of avoiding all difficulties in photographing a face is either to use a long-focus lens or to make a subsequent selective enlargement which shows the face so big that the background simply disappears.

Harmonizing clothing, hair and background

The background should not only be as indistinct, as uniform and as far away as possible from the subject. It should also bear some relation to the model and the costume. Professional models are instructed to suit their gear to a given background. However, you yourself will probably not have the opportunity of tearing your models' clothes from their backs in order to deck them out in what you consider to be suitable garments. So you will have to suit the background to whatever dress is available.

One occasionally hears the simple advice to follow the rule that dark clothes must be taken against a light background, because this allows them to stand out clearly. Conversely, it is considered obligatory for light clothing to be placed in front of a dark background. This is by no means always applicable. One might even go so far as to say that it is seldom true.

It is usually preferable to have a dark background for a dark-haired girl dressed in black, and a light background for someone in a clean, white shirt. It naturally depends on what you wish to emphasize most strongly. Let us imagine that we are photographing a model wearing a black jumper. We will give her nice dark hair – jet black, just as Mother Nature or her hairdresser has made it. If we really want to get a face full of expression, we shall in fact choose a dark background. The face, and, if they are

shown, the hands will emerge luminous from the surroundings. It would be crazy to object that in this arrangement such or such part of the body does not stand out clearly enough from the background. I personally would not be sorry if only the face and the hands could be seen in front of a dark background. But one can if necessary separate foreground from background. For this we must either have a source of light behind the model, or, preferably, ensure that the background is not black, but grey. If, however, we give less importance to the face than to our model's figure, we shall arrange a full length photo with the most effective pose against a light background. If the black, or even the dark figure can justifiably be made to stand out dark against light, it must be graphically decorative.

Now let us imagine the girl's colour scheme is the reverse: her dark hair becomes fair, and the black jumper is exchanged for a light one. If we are still chiefly interested in her face we shall choose a light background, so that face and hands show up in contrast to their light surroundings. To avoid putting forward a one sided argument I should like to point out another possibility of dealing with features demanding the maximum attention.

Let us take the case of a dark-haired beauty wearing a light-coloured dress: we could then try to emphasize the dark eyes, black eyes, black hair and heavily made-up lips. Skin, clothes and background would be scarcely distinguishable – in extreme cases not at all – but would appear as one common light area. It goes without saying that the figure of a blonde in light clothing or in none at all will stand out effectively from a black background. Yet the danger exists of giving the model an unwanted ghostly appearance. The fact is that our eyes, looking at a light object in dark surroundings, see it as whiter than white. (This phenomenon is known as "simultaneous contrast"). It explains why nude photographs or full-length pictures of blondes wearing lightcoloured clothes are nearly always made with a light or grey background. If the background is pitch-black the figure should receive contrast-giving side and rear lighting. Soft front light should be avoided, because it tends to produce pallid skin-tones. It should be added that a moderately dark-toned model in front of a light background is shown with a powerful plastic effect, a fact which explains, incidentally, the preference for dark surfaces

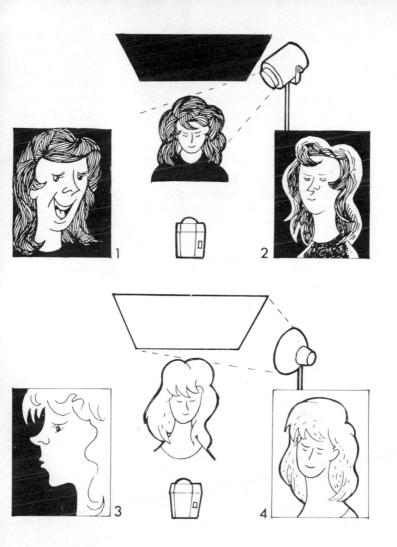

Harmonising background. 1. Dark backgrounds are suitable for dark-haired, dark-clothed models when you want a luminous, expressive face. 2. You can separate the model from the background by rim lighting. 3. The light-haired model should normally be against a light background but the dark background may be preferred for profiles. 4. The light background allows the flesh tones to show modelling.

as background for nude photography. Light tones also create an atmosphere of space, whereas jet-black surroundings seem to imprison the model.

I do not however wish to create the impression of knocking the dark background. On the contrary, people wearing brightly-coloured fancy dress, particularly if they are dark haired, come out especially well in front of a dark background. This goes for black-haired people who normally wear more brightly coloured outfits and who need heavier make-up than fair-haired people. Neutral black on the one hand gives colours greater intensity, and may on the other hand harmonize different colours which would otherwise be too gaudy and might possibly clash.

Before leaving this section I should like to make one fundamental point about style in dress. The simpler the outside shell, the more effective is the kernel within; that is, the face. A simple, plain pullover, an opennecked shirt, are more effective than the most expensive outfit. Besides which, simple clothes are relatively timeless. Pictures of this kind can be shown to your great-grandchildren without comment on the "funny fashions."

Whiter than white shirts and blouses are not particularly suitable for photographs. They reflect the sunlight or artificial light too harshly from below on to the neck and chin. This can often be noticed on TV discussion programmes. Your model should therefore wear a slightly greyish or bluish blouse, rather than a "super-white" one.

Using high and low viewpoints

Most cameras, or at least most 35 mm cameras, are meant to be used at eye-level. This, first of all, means the photographer's eye-level, but in many cases it applies equally to the standing model. However, many a twin-lens reflex camera seems to be designed so as to suggest that we should view our model from chest level. But, especially for portraits, it is absurd to have the shooting position dictated by the camera. We must decide the position for ourselves, according to the character of the face before us.

Many faces can in fact be taken from eye-level. But if, for example, our model is somewhat bull-necked, we must hold the

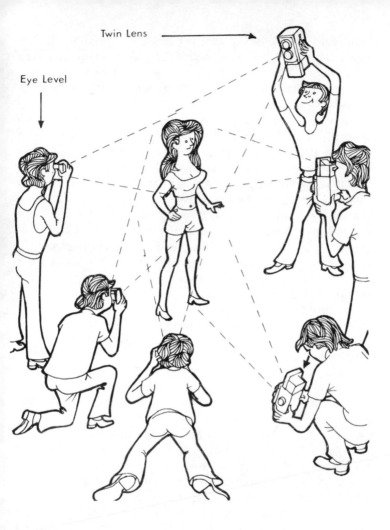

Twin Lens

Eye Level

Shooting angle. The camera should not be allowed to dictate. The eye-level camera can be used equally well kneeling or lying down and the waist-level type can be used from high and low viewpoints.

camera a little higher, so that it looks down from above. The neck will then hardly appear at all. And in no case must one use a low camera position for those masterly personalities who, as is well known, have aggressively prominent chins that need no exaggeration.

Conversely, do not photograph highbrows and egg-heads from above. They are best taken from a low view-point. An overlong nose can also be shortened by using the low position, whereas a high view will lengthen it immeasurably. If the distance from nose to upper lip is too great, the camera held high can make an optical correction of the irregularity.

These are naturally only rules of thumb. Fundamentally it is unwise to lay down a norm without having the model in question before your eyes. But, if you ask me, trustingly, what you should do when you want to take a picture immediately, when you are not at all clear about the camera position. I can only give you this advice: you are more likely to get a good picture from a slightly low camera position.

My remarks will, I know, rouse photographers of the old school to fury. The majority of them avoid the low position as they would the plague, on the grounds that from below the victim's nostrils can be seen. But for one thing I am not disturbed by seeing a person's wide-open nostrils, and for another thing they can quite easily be hidden: the head can either be slightly lowered or turned a little to one side.

Certainly, photos from below were frowned upon not so long ago, and by some people they still are. But here, as in so many matters where taste is concerned, a change seems to be taking place. Just look at the pictures you see in collections of photographs, and note the position from which they must have been taken. You will observe that in most cases it must have been below eye-level. It begins a few centimetres below the chin and reaches down to the toes. You can see that to get some of the pictures the photographer must have thrown himself down on to the ground.

An illustrated magazine once published twenty photographs of models. The readers had to choose the prettiest among them. Twelve were taken from below, four from above and four from eye-level. I need say no more. There are several reasons why the lower view is preferred:

1 From this position it is easier to obtain an uncluttered background such as the white or blue sky, against which the body or the head stands out in clear relief.

2 The low viewpoint emphasizes somewhat the feminine bosom. Illustrated magazines wishing to give their cover-picture a sexy look generally use a photo taken from a low position. If on the other hand the photographer sees a chance of plunging indiscreetly into a low cleavage he will of course take his picture from a higher level.

3 In full-length photographs taken from a very low position, the legs are optically lengthened. Even the ''right plump to see'' young person acquires something of a long-legged gazelle-like grace when the camera is quite literally laid at her feet. The camera must be at some distance from the model in order to avoid any exaggeration of the pelvis.

Fashion photographs are almost invariably taken from waistlevel or below. The majority of nudes are also taken with the camera at waistlevel. Exceptionally, a recumbent nude is not photographed from above, but rather with the camera at the level of the surface on which the model is lying.

I have now suggested to you three reasons for preferring a low camera position. All of them depend to some degree on the fact that the view from below emphasizes outlines. When we discuss silhouettes we shall return to the question. But I still have not mentioned the most important reason for preferring a low camera position: namely, that it puts the subject of the picture in a superior position. This is because the viewer is obliged to put himself in the camera's place and look up to the model. It is true that really great men or women – inwardly great, I mean – have often been so small when seen from the outside that physically big people could have spat on them from above.

Nevertheless, we all have an instinctive feeling that what we look up to is more powerful than ourselves, and that what we look down upon is weaker. The social ladder from office-boy to managing director and inversely is climbed upwards or downwards. Many employees in the middle, who are possibly of middling character, indulge in the self deception of bowing and scraping to those above them while treating those below them with con-

tempt. An officer usually has people above him, whom he looks up to, and others beneath him.

The Xingu Indians of Brazil believe that the man is far superior to the woman. The seating accommodation for the husband, therefore, is on a higher level than his wife's, so that he can look down on her. Even the thrones of European rulers are placed higher than the seats of their subjects. Whenever one person sits at another's feet – the child at his grandmother's, the young man at the feet of his beloved – the person in the higher position is in the place of honour and, for the moment, at least, superior to the person looking up. In ancient Israel an individual expressed his subjection by washing the feet of his superior.

The cinema simply glories in opportunities to suggest superiority by low camera shots and inferiority by high shots. We too will photograph a very modest, dreamy or obsequious kind of person from a high-point in order to emphasize his character. The oppressed, if a social-political protest is intended, are pictured as being observed from above.

In the case of children's photographs the question arises as to what attitude we wish to adopt: shall we take the picture from below in order to show the care-free nature of their childish games? Shall we see the child with the eyes of his young companions, or shall we represent his diminutive size and his helplessness by looking down on him from above with the eyes of a respectable adult?

To return once more to the pictures of women, in which there is always an element of erotic appeal: here again the photo from below stresses superiority and power, expressed in the charm of a charming woman. On the other hand the downward view can emphasize her resignation. In the case of a man, enterprise and dynamism can be underlined by a low camera view. It would be quite wrong to photograph the real, tough gogetter from above. Strong will and ambition can be further emphasized by placing the body diagonally across the picture.

Posing
the
Model

Hardly anyone's face looks the same from both sides. This means that nearly everybody has one or more viewpoints from which he or she can be photographed to best advantage. Mr. X may perhaps look more interesting in a side view. The outline from the top of the forehead, over the nose and chin, as far as the neck is especially characteristic. This we know as a "striking profile".

We are apt to conclude that someone possessing a profile of this kind has a strong personality. Rightly or wrongly, Miss X, with her up-tilted ski-jump nose, is less strongly characterized, both inwardly and in appearance. So we take her photograph full-face from the front. Although this type of portrait does not bring out a person's character so clearly as the profile, it is nevertheless very popular today. In my opinion this is because the full-face photograph seems to look you straight in the eye. This establishes an immediate contact between the subject of the portrait and the onlooker, who feels that he is being spoken to personally.

The place of the profile

Profiles, except for those taken against the light and those in silhouette, do not occupy an important place in modern portraiture. Even those people with strong profiles and who should theoretically be taken in profile, are not so treated. The reason for this would seem to lie in the detachment of a person whose gaze is directed obliquely out of the picture past the person looking on. What is more not every historical period or cultural milieu has left the artist free to choose between the full-face and the profile – not to mention the back view. I would almost go so far as to say that freedom or some restriction in the matter of representation is in some way a measure of individual liberty in any given environment: whether a man was free in his every movement, or whether he was restricted by social or philosophical taboos.

In the golden age of classical Greece and during the period that followed, man could express his personality fairly freely. Consequently artists and sculptors allowed themselves the freedom to make their portraits with a full-face view, in half-profile or in profile. The majority of classical heads have pure contours.

In the Byzantine epoch in Greece and in Slavonic areas represen-

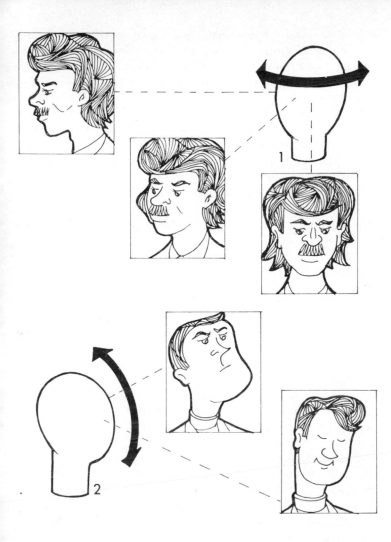

Posing the head. 1. The viewpoint or the attitude of the head can present various aspects from profile to full face. 2. Tilting the head upward or downward can emphasise chin or forehead and thus influence the mood.

tational form was restricted in the same way that man himself was confined in a correspondingly narrow, state-controlled hierarchical structure and a severe religious and philosophical order. For exalted religious personalities and members of the ruling class, there was a marked preference for the strong, frontal portrait. The clear-cut profile, so beloved by the artists of classical Greece, was taboo. Indeed, wherever there existed a strong governmental regimentation of public life, the profile view expressing personality enjoyed little favour. In the Byzantine period one man only was shown in profile, namely Judas Iscariot, the traitor. He was evidently not highly respected. Most portraits of the time were in a sort of half-profile, a mode of representation that I should qualify as being the most courteous, perhaps the most honest of all.

The half-profile, the mid-way position between full-face and profile, together with its variants, the quarter and three-quarter profile, is the most suitable view for flattering a face, a countenance, a mask, or even a mug into being something almost "beautiful". No wonder periods like those of our fathers and grandfathers, and individuals that put social conformity above all virtues, loved the half-profile above all other head postures.

The half-profile may not always show a lifelike resemblance. One indication of this is that the police do not use half-profiles in their criminal records; they prefer full-face photos together with two pure profiles, one facing left, one right. This is on account of "special peculiarities" which may appear on the face. In point of fact, criminals are indivualists, though the converse may not hold. Scoundrels must at least have personality enough to have the courage to put themselves beyond the bounds of society. But the thoroughly assimilated criminal, who uses the criminal designs of society as his own docile tool, has no character, not even a bad one. His photograph often does not appear on the files of the rogues' gallery.

As we have digressed from the subject of photography to our present theme, perhaps I may be allowed to suggest some of the consequences. The ideal of adaptation to society put forward by psychologists and pedagogues cannot and must not be the objective of educational and propagandist measures. We must preserve our freedom to examine without any preconceptions the

claims of any particular demands of society to be just. Critical examination may show us that conformity is not in the circumstances to be recommended. So the fact that a onesided form of non-conformism is practised by individual criminals is not tantamount to a condemnation of nonconformity as such.

I may have given the impression that I would reject the half-profile as being a pictorial expression of a conformist human being. But that is not the case, although just at present this method of representation is not so popular as it once was – which is perhaps a good sign. My meaning is that in a free society every over-rigid restriction of pictorial art is to be rejected. Every possibility should be tried out. Moreover, the psychological and cultural implication of the head and body postures is in reality only one side of the medal. It frequently happens that the shape of the head will suggest the viewpoint, without taking into account any of the conclusions we have been drawing. (All these rules and suggestions only express one individual point of view. So they may be applicable in most circumstances, but should not be applied regardless in any individual case).

Choosing the right side

It often happens – usually, in fact – that it is important to discover which side of the face to take in profile, when the person is to be shown attractively or characteristically. It is an error to assume that both halves of the face are identical. Most faces are only very roughly symmetrical. Women, of course, know which is their better half, that is, which side shows them at their sweetest.

Quite apart from the configuration of the particular face, the head should usually be shown turned from left to right. The opposite view gives a certain tensenes to the expression. Why is this? There is a reason for it. Most people, though not all, scan a picture with their eyes from left to right, though this may be done quite unconsciously. It seems to us that we look at the whole face *en bloc*. In reality, however, our eyeballs are moving so rapidly to and from that we do not notice the movement. Everything in the picture, therefore, that flows from left to right, i. e. in the same direction as the movement of our eyes, gives us a feeling of achieve-

ment and progress. But the opposite movement – from right to left – implies resistance to our own movement. A sailing ship shown ploughing through high seas from left to right shoots rapidly with all sails set over the billows. Seen travelling in the opposite direction, it appears to limp painfully through wind and weather.

If the head and the eyes of a portrait go from left to right they emphasize the youth and attractive candour of a face. Turned from right to left, the face looks somewhat hostile, puzzling, tense. Now since faces attract us particularly when we cannot decipher every detail of their owner's character, the tense picture has something to be said in its favour. It leaves with us an element of mystery.

But we will not exaggerate. This is just one question from among many: the posture of the head cannot by itself be a decisive factor in the effectiveness of a picture. There are other things to be considered. A criminal face remains a criminal face, even when it looks to the right. And a nice healthy face – the sort used to advertise toothpaste or toilet soap – will not assume a sphinxlike impassivity simply by turning from right to left.

Head portraits and body posture

Body posture plays an important part in a portrait, even when the portrait shows only part of the head down to neck level, and even when just one detail of the face appears, from the eyes to the mouth. For the body posture has an influence on the facial expression. Quite apart from this, however, a portrait is more lifelike when there is a certain contrast between head and body position; that is, when the head is turned in a different direction from that of the trunk.

One can think of several different arrangements: the body may face directly to the front, while the head is slightly turned in half-profile. Conversely, the body can be turned partly or completely sideways, while the face looks straight at the camera. When the body in a portrait is turned to one side, the stern, solemn dignity of the face is softened somewhat.

A particularly attractive portrait can be made by pointing the cam-

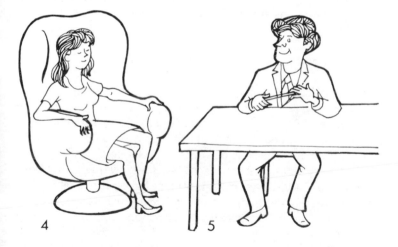

Body posture. 1. The straight-line pose presents a severe appearance. 2. A softer effect is obtained by introducing curves and a semi-profile. When head and body turn to different extents, an element of spontaneity is introduced. 4. A relaxed effect is provided by an easy chair. 5. The problem of what to do with the hands can be solved by using a table as a prop.

era at the model's back, while she turns her head to look over her shoulder. If the person to be photographed can be induced to look over his or her shoulder when you call out, you will get an element of spontaneity into the picture. The looking back attitude cannot be recommended, however, when the neck is bare – in bathing-costume pictures, for example, because the twisting of the skin results in ugly creases. A backward glance with a bare neck turned hard round is only permissible in portraits of tough he-men. With them the creases do no harm – on the contrary, they add to the effect.

Now I am not maintaining that a portrait becomes uninteresting when body and head are turned in the same direction, but a strong countenance in equally strong profile can be deeply impressive. I am thinking particularly of the portraits of the early Italian Renaissance. The fascination of these pictures is produced by an almost ornamentally strong head and body profile. Durer seems to prefer on the other hand the half-profile. With him too, the head and trunk are usually turned in the same direction.

The eyes and the direction of their glance

Once we are quite clear that nothing in a portrait except the eyes need be sharply focused, the principal guide-lines for portraiture have been laid down. The eye, traditionally the mirror of the soul, is the chief medium of communication between a human being's inner nature and the outside world. With its help, more than by that of any other of the senses, he becomes aware of what goes on outside himself. To some extent his sense of sight enables him to draw his environment into himself. But it is also through the eye that he reveals most clearly to the outside world what is going on within him.

When storms are raging in his mind, his eyes flash angrily. The eyes can smile, sparkle and beam. They can also look through one or over one's head – and by whatever they do they reveal a certain state of mind.

Is it any wonder that the eyes are of such decisive importance in the effectiveness of a portrait? I have seen frescoes of saints on the walls of the church of Saint Sophia in Salonika; they have

withstood the passing of centuries. Only the eyes have been scratched out. The Turks mutilated these sacred works of art when they conquered the town. They feared the glance of the beings who were worshipped by their political and religious adversaries.

An old oriental traditional belief was that a man's envious or even admiring glance could bring misfortune, especially to children and domestic animals. In Greece even today donkeys, mules and horses wear strings of blue beads on their bridles as a protection against the evil eye.

It is a fact that eyes that gaze directly out of a picture can be really frightening at times. At least they draw the attention of the observer and get him involved. This is especially so, of course, when not only the eyes but the whole forward-facing head stares out fixedly from the picture.

It is sometimes maintained that in no circumstances should the model look straight into the camera. After all we have discussed together, you can readily understand that I cannot at all fall in with this opinion. True, snapshots taken of someone who is looking into the lens sometimes show that the model has noticed something. The unwilling model should remain unaware of the snapshotting, at least until the click of the shutter draws his attention. But a few pictures in this book, snaps of people looking into the camera, are proof that even in this case the direct look cannot be ruled out altogether. Even in carefully composed pictures, nothing can be said against the into-the camera look which speaks, as it were, to the observer.

A lowered head, with the eyes looking up to the camera, can appear observant, shy, or if combined with a fleeting smile, cunning or mischievous. If, however, a creature of the female sex, with head thrown back, glances down, obliquely if possible, at the person looking at the picture, this too can mean all sorts of things – "I'm feeling seductive today", or "So you think you'll get me, do you?", or, if the requisite accessories to suggest a certain milieu are available, "Price guaranteed inclusive".

However, to avoid all misunderstanding I wish to point out that this ogling technique will not ensure credibility in the case of every female model. You get a completely different expression if the downcast eyes do not meet those of the viewer, but drift away,

so to speak, beneath the lower edge of the picture. This gives an impression of humility or of calm composure, or of being deep in thought. Eyes looking over the top of the camera are directed towards heaven. There are some statues of Alexander the Great with this rather touching heavenward gaze. It guarantees the ruler's standing with the celestial powers. The monuments of the first Christian Roman emperors copied what was known as the Alexandrine look, though the political methods of these rulers were far from being as exaltedly orientated as their lip – or rather – their eye-service. But that is just one of those things.

Generally speaking, the direction towards which the body turns, the one towards which the head is pointed, and that followed by the eyes must all be different. For your first attempts and as standard practice I advise the following procedure. Assuming that the body is turned in one direction while the head is turned, say, slightly to the right, the eyes must be turned even farther to the right. If the head is turned left, let the eyeballs roll even farther to the left. If the head is thrown back somewhat, the eyes must look up still higher. If it is slightly bent in comparison with the body, then the eyes should be lowered still further.

The most effective arrangement in my opinion is the spiral: it works something like this. The body is turned hard left, and the head is turned forward in half-profile. In addition the head is thrown slightly back, and the eyes are turned rather more to the right and also upwards. With all this the model may either look at the observer or over his head or past him.

In the history of art there are important examples of the spiral ploy, such as the portrait of Hendrickje Stoffels by Rembrandt (c. 1658), *Le dejeuner sur l'herbe* by Manet (1863), and *Woman in the blue shawl* by Picasso (1923).

This posture of the human body is used also in fashion, portrait and publicity photography. But what happens if the head and eyes turn, not in the same but in opposite directions, when, for example, the body is photographed from directly in front, while the head turns left, but the eyes again look to the front?

This may produce completely different effects. Some pictures of this kind are sparkling, especially if they can avoid giving the impression of having been posed. If in addition the eyes look straight into the lens the photos sometimes look like genuine

Dancer of the Orpheo Negro Folklore Ballet in a state of ecstasy. Lighting was from a single flash source placed low down.

Conventional portrait with imaginative lighting. The head is isolated by the dark clothing and surroundings. Illumination was from a single flashbulb to one side and slightly above.

An impression of camp fire lighting created by lights placed low down to illuminate the face as Nelson Ferraz, Brazilian-born folk singer, sings a song from the days of slavery.

Harsh sunlight is not normally recommended for portraits but it is well suited to exaggerating the characteristics of a face that has seen its fair share of sunlight and outdoor life. Wide-aperture shooting isolates the head against an almost totally defocused background —*Michael Barrington-Martin*.

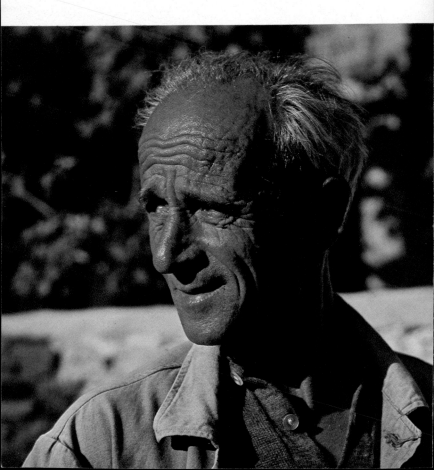

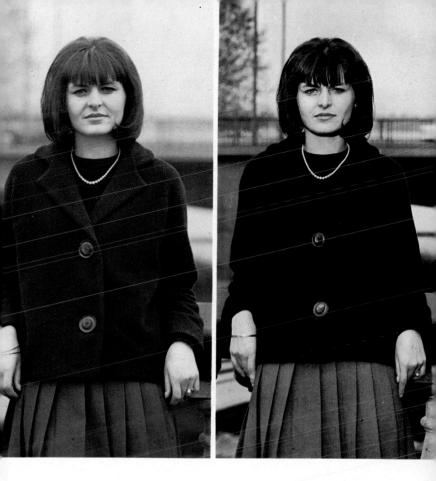

The dull weather portrait on the left shows the usual tendency to colour distortion. It is brightened considerably by the use of frontal flash which puts life into the hair and eyes and produces a better colour rendering. Frontal lighting also has the advantage of softening shadows on the face.

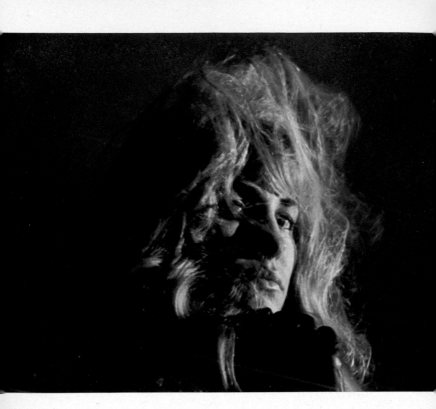

The blue background, directional lighting from a halogen lamp and an artificial light film give an impression of a chance night-time shot.

The average bathroom has the great advantage of providing ample reflecting surfaces to relieve the shadows of flash or photoflood lighting. If you use photofloods you have to be very careful not to let water splash on the hot lamps—*Richard H Parker*.

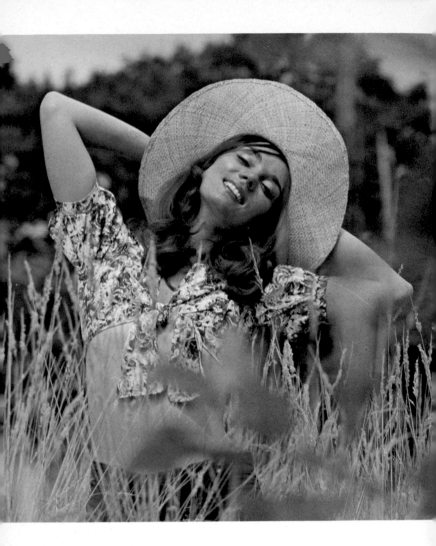

An out-of-focus foreground adds depth and interest to an otherwise straightforward shot—*Michael Barrington-Martin.*
Opposite top: Keeping the subject's face in the shade avoids harsh contrasts and deep shadows. *Bottom:* Sand is a good reflector of light for back-lit subjects—*P C Poynter.*

The problem with this type of shot is to shade the lamp illuminating the face so that it does not shine into the camera lens. This was a flash picture. With continuous lighting you have to make sure that the mirror is held very steadily.

Side back lighting has lit the hair to perfection. This is a case, however, where the fill-in frontal lighting is a little too high and too harsh. A broad, diffused light or simply a reflector would have given a softer rendering of the face—*Michael Barrington-Martin*.

Page 82: Soft lighting to flatter the complexion was here supplied by umbrella flash —*Leslie Turtle*.

Page 83: A window forms a useful light source that can cover a reasonably large area. The rate of fall-off depends on the size of the window—*Anima Berten*.

A young Greek shepherd boy. Exposure had to be ample to obtain detail in the face, shaded by the cap peak.

Opposite: It is not advisable to shine powerful lights in a baby's eyes but you can light from the back and expose for the shadows. Some loss of definition and colour is likely.

Children and animals are an appealing combination for greeting cards, confectionery boxes, etc. Full illumination and pin-sharp detail are obligatory—*Richard H Parker*.

snapshots – rather as if the subject had looked up with some excitement, surprised at the very last moment by the release of the shutter. In point of fact things do happen like that in genuine snapshots. On the other hand, a glance in the opposite direction from that in which the head is turned may make the woman look coquettish. The eyes seem to be half (or three-quarters) saying Yes. But with this there is the very great danger that this kind of picture may slip very badly into the carefully thought-up, artificially posed class of photo.

It is usually essential that the eyes appear to be focusing on something rather than just staring vacantly. They should either rest on the observer or on some point outside the picture area. Sometimes, of course, the object of interest can be within the picture area. The model can look at her hands, read a newspaper, admire a flower, or else pay attention to another face which might just be shown in the photo. In this case the motivation for the direction of the glance would be supplied by the model himself or herself.

Getting the right pose

I have now explained to you which postures your model should adopt in order to get the best result. But one question remains to be answered: How do we get our model to take up the pose in question?

This is what I do. The camera is all ready for action on its stand. I hold the cable release in my right hand, ready to press at any moment. My victim's body is in the right position, facing the camera, I now ask my model to watch my left hand, which I move about in the air, up, down, to left and right. The model first of all follows these movements by moving his head. When the head is in the position I want. I ask him to keep his head still, but from now on to follow my hand with his eyes only.

The movements of my hand are followed one after the other by head and eyes in a series of positions from which I can choose the most suitable. If I were to try to give directions by word of mouth: "Head up higher, hold it, a bit lower, hold it, now a little bit to the left – no, I mean right – keep your head still, only move

your eyes now – higher... higher'' and so on, we should both go mad before we get anything like the right position. The conductor's hand makes things easier for all concerned.

It goes without saying that we start from the assumption that we have ordinary human beings in front of the camera, not professional models or actors. Models, of course, know all about their photogenic attitudes and are able to adopt all manner of positions rapidly and of their own accord. Besides which, I consider that a sympathetic non-professional subject, possibly surprised by the click of the shutter, behaves in nearly every case more realistically than a professional.

Actors, perhaps after a rehearsal or a performance, ask to be told in what part of what scene they are to be photographed. They then put on a show: that is, they repeat bits of the script in order to get themselves back into the dramatic situation. When I photographed Marcel Marceau in connection with some performance of his, he asked me to tell him which bit of pantomime I wanted to take. He was then in a position to adopt the desired pose and to keep it as well. Other actors seem to find this difficult.

Whenever it is feasible to take snapshots during a rehearsal, this is much preferable to any pose taken up when the show is over. An exception to this rule must be made for dance attitudes, which nearly always have to be posed.

Although I am of the opinion that a non-professional model should allow himself to be guided or coaxed by the photographer when he attempts to strike dramatic attitudes in front of the camera, I do not deny that it is occasionally possible to get a born actor in front of the lens. Not only that, but scenes from amateur theatricals, school and kindergarten performances can make charming photographs. Unfortunately the corresponding scenery is usually too clumsily arranged. Too many producers want to be in the picture and the background does not receive enough attention.

The relaxed look

When the question of posture has been solved, it goes without saying that we have the facial expression to watch. Apart from eye

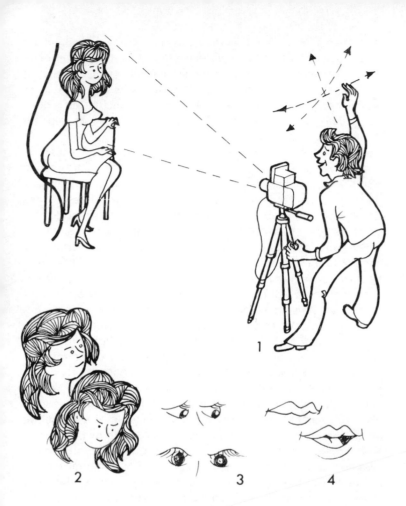

The pose is a combination of body posture, head position, direction of glance and set of mouth. A convenient method of controlling the sitter's head position and glance is by means of hand signals.

movements there are not all that many possibilities of modifying individual parts of the face. Waggling the ears is strictly confined to the Golden Silents of the cinema, and nose twitching is not particularly recommended for effective portraits. It is possible to wrinkle the forehead both vertically and horizontally, but it does not usually come off. Grimaces of this kind should be kept for photographic caricatures.

So we are left with the mouth as our only other expressive feature. It used to be easy. The victim had to say "cheese". This caused a contraction of the facial muscles which, when hard put to it, people could interpret as a friendly smile. Even now "cheese" does its job when somebody wants to be shown smiling in the photograph. But who wants that anyhow? The truth is that the smile, which had a long innings as a necessary adjunct of a portrait, only came into photographic fashion in the 1920's. Today the unattractive, conventional stock smile has had it. Only in the most exceptional cases is it considered worth having. What people admire today is a sincere, calm face, perhaps a genuine laugh, but no longer a smile. To be exact, it is only the conventional smile that is condemned. The real smile that comes from a person's feelings be it ironical, malicious, relieved, excited or embarrassed – is always worth capturing in a photograph.

Another lip movement, much used nowadays for pin-ups, is supplied by the open mouth. This is supposed to suggest spontaneity. It is sometimes sensual, more often stupid; there must be people about who can't distinguish between the two.

Now it really is not worth the trouble to produce a synthetic expression. Good professional models and a few natural mimics can do it. But there are less of them than one might think. And in any case I consider it better to try, somehow or other, to get a genuinely spontaneous expression.

Unfortunately people have a natural tendency to put on a photographic face as soon as they feel that the camera is pointing at them. It does not help one little bit to get them to unclench their teeth or to "open wide", as if they were in the dentist's chair. It is equally futile to demand of our victims a tortured grin.

"Photograph face" is caused by the nervousness, the fear and the helplessness a human being feels in front of the camera. Basically nearly everybody feels flattered at being photographed. On

the other hand, who is going to admit as much? Everyone, man or woman, is ashamed of showing it. The result is a strange dichotomy of feeling: on the one hand eagerness, on the other unwillingness. Martyrs of the camera suffer agonies. Women are rather better about it than men: for them it is the most natural thing in the world to assume the most favourable posture, not to be chary with their charm, but to lead it into battle. If they were not like this one would diagnose a hardening of the arteries. So for them it is not so difficult to adopt a pose as it is for men. Nevertheless even they have butterflies in the tummy when they see fixed upon them the camera's pitiless eye.

Presumably they are terrified lest the apparatus should create an imperishable and indestructible document about them. What ghastly visions of shiny noses or crumpled pullovers may not haunt their mind at the click of the shutter, in that $1/100$-second moment of truth?

So we must ensure that we distract our model's attention in some way or other. At the moment of the click she must be thinking of anything but the click. One method that has given good results is the sham exposure. I pull out the film-transport lever of my camera and let it swing against the metal body with a click. With most cameras the noise can be produced in this way, and most people in front of the camera fall into the trap – and their expression becomes relaxed. Sometimes there appears a smile of relief – a genuine one – and I quickly press the release. You can get away with this twice or possibly three times with the same model after which, of course, the cat is out of the bag. The person concerned has got his ear in, and can distinguish between the sham click and the real one.

Most cameras are equipped with rapid film transport facilities. This allows us to make the exposure in the first place, no matter whether the subject is tense or relaxed; then the film is swiftly wound on and a shot made with the reasonable certainty of getting a relaxed expression.

The other possibility of distracting the model's attention is by provoking as controversial a conversation as possible. The photographer should know in advance what his model is interested in and lead up to the topic accordingly. During the dialogue he makes his exposure. If he is using photoflood lamps he must be

prepared to talk a donkey's hind leg off. In the first moments after being switched on the lamps dazzle the model, and the eyes are blurred. After five or ten minutes the eyes get accustomed to the light, provided only that the photographer has succeeded in distracting his victim's attention. It goes without saying that the photographer does not release the shutter once only; he makes six or seven shots. Afterwards he can pick out the picture with the best expression. If he happens to have scored several bulls, so much the better. Personal or flirtatious remarks are sometimes successful in provoking a spontaneous reaction. "You're looking very beautiful today" may well be rewarded with a smile.

Another well-tried method of distracting a person's attention before a snapshot is the unexpected exclamation. To get a child or a girl to turn towards the camera, you suddenly say: "Just a minute, please" or "Excuse me". Immediately the astonished gaze meets our eyes we take the snap. In one of his lectures Walter Benser showed a fascinating picture of a young Chinese girl. She had her back turned to him. He called out to her, she looked round, he made the snap, and she disappeared into the crowd. Even when someone is sitting for a portrait, an exclamation may succeed in relaxing the expression. We make our model look up or look back. It is most important to take the picture as soon as our cry has been successful. Let a few seconds go by and the face has already closed up again. The whole art consists of putting the model at ease, so that at the moment the photograph is taken, he or she is concentrating on anything but the photograph.

Of course you can object that the gestures of professional models today are anything but spontaneous. That is true, but these people can simulate spontaneity, and can do so quite convincingly. Models of this kind are actors; they may not act a scene on stage or a scenario in a film studio, but they act the moment that is captured by the camera.

Making use of emotional responses

The spontaneous reaction, expressed in the face within a fraction of a second, has not been the objective most eagerly sought after by photographers in every period. But today, when the world is

becoming more and more organized according to strictly intellectual conceptions, leaving little place in business or professional life for the free play of the imagination, an untapped excess of emotion is built up side by side with the powerful forces of reason. But we human beings are creatures who cannot live by reason alone. Our emotions too demand their rights. It is simply asking too much of us to be rational the whole day long without ever giving vent to our feelings, as if to do so were indelicate. As antidotes to the dictatorship of reason which would subjugate our emotional life we have, for example, music and the dance. We can thank the beat generation and the pop groups for providing a compensating factor by arousing an ecstasy which enables many people to let off steam from their pressurized reserves of feeling. Then when the excitement has simmered down, they can again accomodate themselves to an allegedly rational social system.

An easier way of escaping from reason to feeling is by the use of drugs. But this may prove to be a one-way journey. The primitive human way of getting away from the sphere of reality to the world of feeling was by the pure ecstasy-begetting rhythm of the dance. This counterpoise to the new intellectualism has been successfully borrowed from what one quite wrongly described as the primitive peoples. It was only when men had become too feeble to attain ecstasy by rhythm alone that they had recourse to drugs as a substitute. These procure a sort of ecstasy without demanding physical exertion. Some of these intoxicationg preparations, the hard drugs especially, have the disadvantage that in time they block the return road from the realm of feeling to that of reason.

Just as it is quite stupid to believe that a world ruled solely by the intelligence can provide man with a life worth living, on the other hand a life that is guided purely by emotion and which excludes reason leads to madness. To use the understanding in order to create conditions in which men can have a tolerable life; to exploit intelligence in order to keep worth-while living conditions under control seem to me objectives worth fighting for.

Photography is the most important means at our disposal for taking possession of the things of this world which we have, which please us and charm us – in short, those which appeal to our feelings. Everybody has to rig up some sort of environment in which he can live, and if genuine emotion is becoming scarce in ours,

then at least let the portraits on our walls or in our wallet give visual evidence of the powerful forces of our emotional life. Why do I hang on my wall the ecstatic ballet dancers from Guinea, or the ballet dancer of the Orpheo Negro with her face distorted with frenzy? I do so to bring right into my immediate surroundings – in which I have to produce practical, rational work – some compensating factor capable of appealing to my emotional self, an atmosphere of primeval forest, of adventure and ecstasy. What is more, the photographic style of our time, especially in portraiture, expresses a wish, or even fulfils in some way desires that slumber within us, slumber so soundly that we are often unconscious of their existence: longings that have something to do with the representation of happiness and the notion of a paradisiac condition.

Elderly people love photographs of romantic landscapes because these complete their mental picture of idyllic peace and contemplation. The fulfilment of our generation's idea of paradise, shown not only by the flowing locks of the males, which give them their baroque looks and mannerisms, is the subjugation of mechanistic and technological tyranny and the triumphal upsurge of the emotions.

If I am of the opinion that pictures reveal many things about ourselves and our time, you will very likely ask me if other current styles in fashion and publicity also have something to say. It certainly must mean something when a human being appears to have been transformed into a decorative figure – into an ornament. But somehow it seems to me that this incorporation of the human body into some preordained decorative scheme tallies with the questionable demands of our psychologists and pedagogues that a man should conform to society and the community. To every society and to every community?

Who is photogenic?

Every person who finds himself looking into the lens of a camera anxiously wonders whether he is photogenic. Being photogenic does not necessarily mean that the person in question looks beau-

tiful in the picture – although it can have that meaning. The important thing is for the person photographed to be full of character in the portrait. Just look at the pictures in this book. A minority of the people represented are beautiful, or handsome in the ordinary sense of the words. Yet somehow they all have their individual character. At least, that is what I find. You, possibly, are quite unimpressed by this photo or that – but I as the photographer am naturally prejudiced.

So anyone whose face appears expressive in the photo is photogenic? The modern style of portrait, which values spontaneity above everything, enables you to make anyone's photograph expressive. I am the last person to underrate the value of skilful positioning of the camera or suitable lighting in making the person appear more significant, more beautiful, more feminine – or even more foolish. But more important still is the life like expression. And to obtain this the photographer's victim must either get rid of his tension himself or be helped out of it by the man with the camera. Perhaps I can make it easier for you to relax if I say this. Every human being, including you and me, is vain. That is human nature, which can neither be changed nor concealed. Seeing that there is nothing to be done about our vanity we might as well admit to it frankly.

I should like to lay it down as an axiom that there are no photogenic or unphotogenic people, just tense and relaxed individuals – as well, of course, as clumsy photographers. Anxiety is as unphotogenic as relaxation is photogenic. A photograph of a genuinely lively expression or of a spontaneous gesture is always effective. On the other hand, for those decoratively graphic pictures of which we have spoken, we need people whose impassive face comes out well in a photograph. And not everyone is suitable for this – yet we cannot admit failure.

Snapshot technique

I make snapshots of my friends, bring down actors from the stage with a shot from my camera and I like to go about unnoticed in foreign countries, taking snapshots of popular scenes. Why I do

so is hardly necessary to justify after the long dissertation about spontaneity.

As a photographic sharp-shooter you will undoubtedly find it an advantage if your camera has a long-focus lens. The greater distance from your quarry will give you the opportunity of remaining unobserved.

But even if your camera cannot allow you such refinements, this does not mean that you have to give up all idea of snapshots. Far from it: you still take your picture from a considerable distance and then have an enlargement made of one section. Besides which, I advise you not to use an ultra-rapid film nor a very slow film either. Films of 200 ASA, or even 400 ASA nowadays will give you excellent sharpness. In my experience unsharpness has practically never been because an over-sensitive film was used. In some instances the fault has been attributable to inaccurate focus, but usually it has been a case of camera-shake.

To get sharp definition you must give an exposure of $1/100$ sec or less. In reality the recommended lengths of exposure for snapshots begin at $1/250$.

Exposures of $1/60$ sec or more can only be relied on to give the required sharpness if you can get some support for your elbows or use a tripod. You often hear it said that the longest exposure for a hand-held camera is $1/25$ sec. or $1/30$ sec. That may be true in cases where the photos are not englarged beyond about postcard size. But I must make a reservation here by pointing out that portraits can also be quite effective when they are not so sharply defined as other subjects must be. Unless you are going to make a selective enlargement of the head, you should go up close to your subject. You then focus your lens normally at a given distance. According to whether you are taking a head and shoulders or a full-length picture, this should be between about 5 and 7 ft or 1.50 and 2.50 m. With an automatic camera you must approach your model from this distance only and then, when you see the suitable posture or an interesting expression, up with your camera and shoot.

As my cameras are not automatic I generally standardise my exposure for snapshots. I first of all measure the exposure for an average subject, taking the reading in general from the flat of my hand.

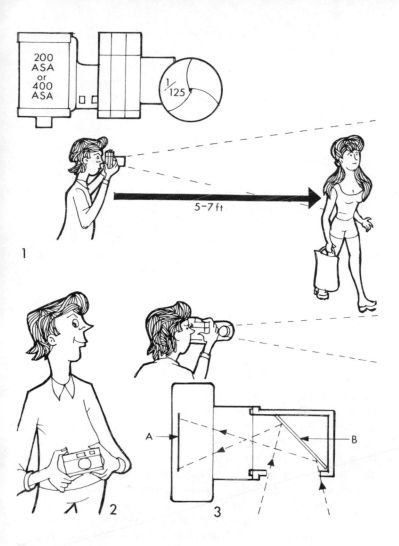

Snapshot technique. 1. For snapshots, a relatively fast film is advisable, with a shutter speed not slower than 1/125 sec. With the standard lens, you need to be within 5-7 feet of the subject. 2. Blind shooting from waist level may enable you to shoot unnoticed. 3. A right-angle attachment allows you to face away from the subject with a single-lens reflex. A, film plane. B, mirror at 45 degrees.

If you consider it important to remain unobserved not only before, but after the exposure, the blind snapshot exposure is advisable. You hold the camera in front of your tummy and tilt it up slightly. This low camera position is useful because it enables you to get a background of sky and to avoid buildings, etc., whose oblique lines might in some circumstances be disturbing, especially when they do not slope markedly, but merely lean back slightly. If you are near enough to your subject then just make a blind shot. If you are *too* close, say less than 6 ft or 2 m, this is not so likely to succeed. Your quarry must have some space around him, so that you do not cut off part of him in the picture. Of course, blind shots occasionally go wrong, so try to make as many shots as the circumstances permit.

The snapshots with the greatest chance of success, however, are those which are made with a spot of direction. Children at play offer highly effective shots of unconsciously posed pictures. Grown-ups, too, can forget themselves in a game. When you are playing Scrabble, or chess, or blow-football, or when your are dancing, you pay no attention to the click of the camera.

Keeping the hands busy

Hands can of course be included in a head picture. They will liven up the photograph, but they are not essential. It is quite otherwise with head and shoulder or full-length pictures. In these the hands must normally be included. (Notice that I speak of the *hands* in the plural, for if only one hand appears, the other should at least be hinted at, or be partially visible.) There is no need for the hands to appear complete with arms in the picture. I have seen some very good portraits in which both hands were cut off at the wrist. Head and shoulder or full-length photos in which the hands are completely invisible, being tucked away behind the back, for example, are only successful in exceptional cases, and need not be considered. I would however point out that a hand can only be said to be missing when it is concealed by the body. Hidden behind a tree, a wall, a window-sill, one or even both hands may very properly be concealed. When possible, however, I try to get both hands completely into the picture. This is merely one of my per-

Arms and legs. 1. If the hands are given something to do, be careful to avoid distortion. 2. Combining straight lines with the curve of legs and body adds interest to the picture.

sonal tastes and need not be taken as having general application. As soon as you decide to include the hands, the question of how and where arises. Well, the arms can be folded, hands placed on hips or supported by some other object; they can wave, hold on to a hat, shade the eyes, etc. There all sorts of possibilities.

In large-scale pictures of the face the head may be propped up by the hands, for example, or the person in the picture can be lighting a cigarette. In cases like this the head can be pruned considerably. In a half-profile even the ear can be cut out. More drastic cuts can be made if the hands play an important part in the picture.

If one or both hands happen to be a long way in front of the face, however, there is a danger of perspective distortion. In this case also the following rule holds good: if the distance between the camera and the nearest edge of the subject is at least ten times greater then the distance between the front edge of the subject and its furthest important detail, there will be no distortion due to perspective. I should like however to seize the opportunity to point out once again that nowadays some degree of perspective distortion is deliberately used to give a portrait a particularly interesting accent.

I should now like to remind you of a very special situation. I am sure you have found yourself at one time or another in this sort of position. You have to face an important interview with some equally important person, an interview which may affect the whole of your future: it may be a contract to sign, an examination, a job, an application to the boss for a rise in salary, or perhaps a proposal of marriage. There you sit or stand and do not know what to do with your hands. This is why in business conversations one participant offers the other a cigarette.

Non-smokers have to make do with a cup of tea or a glass of sherry. While you are telling the lady of your love you are advised to pluck a flower or a twig from a bush and to tear the unfortunate bit of vegetation into small pieces. Ball-point pens are handy for taking apart and reassembling. People who wear glasses, as I do, are in a privileged position: in case of need they can polish the lenses. Ties too fulfil their main function of allowing you to allay your nervousness by adjusting the knot. The Greeks are well aware that smoking is not just a pleasure, but serves above all to

occupy the hands. If they want to give up smoking they play with the *komboloion,* a string with big amber beads. As a substitute, you can jingle a bunch of keys in your trouser pocket. If the hands are occupied, embarrassment is reduced, not only in grim situations, but also in photography. We can overcome the portrait problem of hands very simply by giving our poor victim something to play with, be it a cigarette, a glass of beer, a book, a pencil or, for women, a lipstick.

Portraits gain enormously by showing their subject engaged in his or her typical acitivity. A picture of this kind has more to say than any portrait that has simply been posed. Every job has its photographic possibilities. The housewife at her cooking-stove can perhaps be surrounded by a cloud of steam which with suitable lighting can be most effective. The executive or clerk can be taken writing or calculating, seen amidst interesting piles of documents.

I know very well that many people dislike being photographed at work. If a photo is to be taken, they want to be dressed in their Sunday best, or at least in their travelling outfit. But one thing the person concerned does not realize is the photogenic value possessed by his place of work, and especially how advantageously he appears in these surroundings. A person's ordinary clothes do not deform his image; on the contrary, they distract attention from the face less than party-dress does. It goes without saying that sport offers a mass of opportunities for showing the hands in action.

Positioning the legs

Now what shall we do about legs? We can put them under the table, of course. But then we can't see them, which is sometimes no bad thing. This is by no means always the case, however. If we have to arrange the posture of someone standing up, the best way of tackling the problem, at the first attempt anyway, is to imitate the cunningly composed statues of the ancient Greeks, and use counterpoise. This represents an easy, natural way of standing, in which the position of the arms is in opposition to that of the legs. The old Greek statues never assume an unnatural "stand-

to-attention'' attitude. They tend to put the weight nonchalantly on one leg. The other leg is free, or bent backwards. This produces the casual posture that people normally adopt when they are not subjected to the pressure of some superior authority.

We will call the leg upon which the body rests the standing leg, and the other the free leg. The arms, like the legs, should have different parts to play. One, more or less free arm, moves in easy gestures. The other, the working arm, or support arm, is propped up on something – on the hip perhaps, on an umbrella, on a ledge, or on somebody's shoulder – anywhere it can find support. If necessary this arm too can be allowed to hang limp. The particular trick of the ancient Greeks was that whenever the left foot formed part of the free leg, the free arm had to be the right arm, and vice versa. The duties of the limbs are distributed crosswise, as it were.

I do not mean that this scheme must always be followed to the letter, but it is a good system because it accustoms you to place your model in an entirely uncramped posture. With the aid of this counterpoise it is a simple matter to get the slightly S-shaped body line which is so becoming for standing models.

Fashion photography adopts the convention of exhibiting modishly distorted body postures. This sort of thing is best forgotten, because it is not based on natural counterpoise. A short while ago, for example, models had to stand with their pretty legs wide apart. This sort of thing attracts attention for a short time, but these very contrived postures soon get on the nerves. They are indispositions that can be cured, like measles.

Another thing I find most becoming for the human figure, especially the female figure, is the inclusion in the picture of very pronounced verticals and horizontals. Your model could have as background a rectangular window-frame, or you could use a ladder-back chair in order to get horizontal lines into the picture. Another composition which somehow appeals to us is that of a girl lolling languidly in the frame of a doorway.

I have also seen some strikingly original nude studies. An unclothed girl stood in a sort of framework of iron bars, running perpendicularly and horizontally. I have rarely found an example of nude photography so impressive as this one. On the one hand every parallel with top and bottom edges of the picture, whether

horizontal or vertical, adds in the most natural way to its charm. But at the same time the combination of straight lines with a female body seems to me to have deep symbolism. This makes a profound impression upon our unconscious, so that we find pictures of this kind extremely attractive. The rounded forms of the figure express human emotions and feelings, whereas the straight lines represent man's understanding and his capacity for logical, mathematical thought. As the tension between feeling and understanding is a universal human problem, but one which in Europe corresponds to the age-old theme already implanted in our consciousness by the Greeks, it follows that pictures that visualize this dichotomy are bound to move us to the very centre of our being.

Standing portraits do not fit easily into the limits of the picture. For one thing, the full-length figure comes out too small. It can be made larger in the photograph if it is cut off at about knee-level. And even then, if instead of standing up straight, our model can lean against something or be propped up in some way, the height is reduced by from 4 to 12 in, or 10 to 30 cm. We can then go up closer and get a larger-scale picture. An even better, be-cause bigger, full-size figure is obtained if the model is sitting down, or perhaps kneeling or squatting with bent knees. Even when lying down, a person looks better between the four sides of the picture than he would if he were standing.

And finally we can save a lot of room if we take a recumbent figure along the diagonal of the picture.

A word about make-up

I might as well confess straight away that I am not a specialist in cosmetics. Make-up is in any case so much at the mercy of fickle feminine fashion that there is a danger that anything said today will be out of date in a few weeks' time. At the present moment, as I write these words, eye-shadow is all the rage, something very favourable for photography. The paleness of the lips runs counter to the practice of toning down skin blemishes by the use of warm-coloured filters.

However, we cannot entirely renounce the use of make-up, either for beautifying the face or for correcting its defects. Professional photographers wage war on wrinkles and creases by retouching. This is why they prefer big negatives, whose large area lends itself more easily to painting and scraping. Retouching of this kind is, in fact, only for people with a gift for drawing, and a very steady hand. We prefer to iron out the wrinkles by using soft front-lighting. But we replace the retouching of the negative for erasing spots and pimples – unless we can use filters for the purpose – by making up the face of the model herself.

Various firms have brought out little complexion pencils, which look just like lipsticks. With these it is a simple matter to paint out skin blemishes. This enables us to dispense with filters, or to use them for other purposes.

Almost every kind of skin reflects highlights under direct lighting. The simplest remedy is to powder the parts of the face affected. In full-length portraits imperfections on the face are scarcely visible, but they can tolerate heavy, or even exaggerated make-up. The bigger the scale on which the face is shown, the smaller are the opportunities for using cosmetics – unless you are trying to make a real pin-up picture. Another practical tip: dissuade your model from moistening her lips just before the picture is taken. Wet lips are subject to terribly bright reflections.

I am of course speaking solely of feminine models in these matters. Whether you hide the pores and blemishes of a man's complexion under a layer of powder is a matter of personal taste. For my own part I am as strongly opposed to make-up for men as I am in favour of it for young women. Nevertheless it must be said that extraordinarily attractive pictures of young girls can be seen, which have been made without any extraneous cosmetic aid. Even freckles, especially when they appear in a cluster, are no longer covered up. On the contrary, they are accentuated by using a green filter.

Lighting:
Sun, Flash and
Photofloods

In this chapter, sunlight, flash and filament bulbs are cheerfully thrown together pell-mell. The fact is that no matter what light source is used, daylight is the standard example for lighting in every case. This book would obviously burst at the seams if I tried to go thoroughly into the properties of flash and filament lighting. The practical use of flash is covered by another book in this series.

Flash and photographic lamps

Flash, electronic and the now almost universal blue flashbulb, is suitable for all photos on black-and-white and also daylight colour film. Photofloods are primarily intended for use with black-and-white. They render the red tones and skin-tones somewhat lighter than they are in reality. You can compensate for this effect by using a green or blue filter. In the case of blue filters you may have a kind known as conversion filters, the main purpose of which is actually to allow daylight colour film, rather than black-and-white film, to be used with filament lamps. This makes the colour somewhat warmer. But for portraits that is no bad thing. If however you wish to use colour film both in daylight and with filament lamps, I would advise you to use for preference what is known as artificial light colour film, when necessary with a warm-coloured conversion filter (with a brownish or salmon-coloured tone). This combination saves a considerable loss of light when you are using lamps.

There are two different kinds of photographic lamp. They differ somewhat in the colour of the light emitted. For this reason the film industry has developed two different types of artifical light film, known as Type A and Type B. The Type A film is for use with short-life (2-6 hours) photoflood and tungsten halogen lamps. The Type B film is for use with longer-life studio-type lamps.

As a matter of fact, the differences between the two kinds of light, as also between the different kinds of film, are not quite so important as they may appear here. I have often mixed both kinds of light and used them with one or other type of film. But, one thing must be said: ordinary domestic lamps are not suitable for colour photographs.

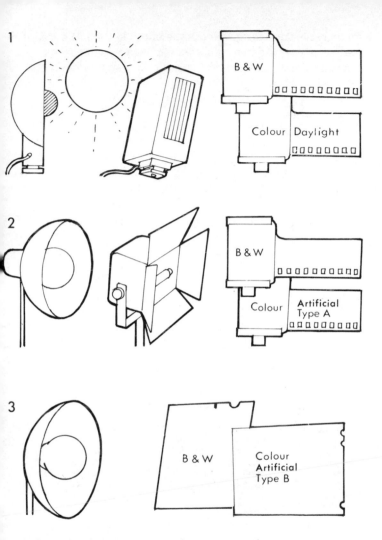

Films and light sources. 1. Most colour slide film is designed for use in daylight. Blue flashbulbs and electronic flash can also be used. 2. Some colour slide films are available in Type A form for use with photofloods and tungsten halogen lamps. 3. Type B colour slide film is for use with high-power studio lamps. Black-and-white films can be used with any light source.

As you may be wondering which is the better source of light for portraits, flash or tungsten light, I should like to point out the advantages and drawbacks of both types in a comparative table.

FLASH AND TUNGSTEN CHARACTERISTICS

	Flash	Tungsten lamps
Control of lighting effect	Effect of lighting must be estimated. This is quite possible with a little experience.	A few lighting effects, but by no means all, must be examined visually.
Dazzle	The short flash causes no dazzle which would later be visible in the picture.	Considerable dazzling. This can be circumvented by indirect lighting or by letting the model get used to the light.
Facial expression	Can be natural, because there is no dazzle, and snaps with short exposure are possible.	Lifelike expression possible, with some restrictions. Dazzle and long exposure make it difficult to capture spontaneous reactions.
Pupils	Shown large if room lighting is turned out.	Iris somewhat contracted.
Use in conjunction with daylight	Flash can be used with daylight without restriction. Either the daylight or the flash can be used as main lighting.	Can be used as supplementary lighting with daylight, only with some restrictions, if, for example, colour distortion is acceptable or desired.

Whatever kind of lighting you use, you can manage with a single photoflood. But the lighting must be sufficiently powerful. A second light-source is very useful, but not essential in all cases. Strangely enough, the possibility of using daylight as a secondary light-source is utilized far too rarely. With black-and-white film, you can use window light in conjunction with flash or tungsten lighting indoors. With daylight colour film, you can use daylight as a fill-in for blue flashbulb or electronic flash lighting.

Lighting with tungsten halogen lamps

For portraiture I am fond of putting a tungsten halogen lamp into a parabolic reflector. It gives such a powerful light that I can illuminate my model indirectly by means of a detour round the walls of the room. In this way I exclude all danger of dazzle. The lamp is in a holder fitted with flaps which allows me to channel the light to the objects I wish to illuminate. If you intend to build up gradually a whole set of lighting lamps, I advise you to limit yourself in the first place to one single 1000-watt tungsten halogen lamp. With this you will gradually acquire the basic skills of lighting technique.

Later on, when you are thoroughly used to using it, you can think about a second light. This would be a small spotlight of some 500 watts. If necessary, it can be improvised quite successfully from a high-intensity projector.

If you think it worth while to introduce a third light source, I suggest a further 1000-watt halogen lamp. I consider powerful lamps to be a practical proposition, because they allow portraits with colour film and also with high-speed black-and-white film to be made if necessary with the camera held in your hands. But in this case the lighting must be direct. Dazzle-free indirect light would not be strong enough. In order to accustom your unfortunate victim to light of this intensity, you will have to let him roast for ten minutes or so with the lamps switched on, while you divert him with your witty conversation. In this way, you can prevent him from screwing up his eyes or from shedding bitter tears. This procedure will allow you, if it is really necessary, to hold the camera in your hands, just as you would for a picture out of doors. But I must just say this: if you do use a stand, see that it is stable – and that also means heavy.

You must be careful not to overload the wiring when connecting photofloods to the domestic electricity supply. The lighting circuit in the United Kingdom usually takes only 5 amps and should not, therefore, be loaded with more than about 1200 watts, assuming a supply voltage of 240. The safe load is calculated by multiplying the supply voltage by the rated amperage. Thus, a 10 amp circuit will take 2400 watts and a 13 amp circuit, 3120 watts, again assuming a 240 volt supply.

If, which is most unlikely, you really wish to go to the extreme limit of your circuit load, you must on no account insert any other current-consuming apparatus at the same time as the lamps. Be particularly careful about refrigerators and ice-trays, because in certain circumstances they switch on automatically at the wrong moment.

Soft light and hard light

As standard portrait lighting I recommend the soft light from an overcast sky. With this there are few if any shadows. The reason is that light streams in from every direction from the whole vault of the sky.

On a fine day this kind of light is only obtainable if the model is in the shade. However, the blue from the sky penetrates the circle of shadow and gives faces on colour film a slightly bluish tinge. An antidote to this is provided by a light pink filter. This diffused light can be imitated, as it were, by flash and photofloods. In a living-room with light coloured ceiling and walls, you must direct the light obliquely upwards. It is then reflected down from the ceiling on to the model. We can now consider the ceiling as being the real source of light. It is immaterial whether you have a translucent area, such as a blanket of cloud, or a large sheet of transparent paper which diffuses the light which passes through, or whether you illuminate a light matt surface which scatters the light in the same way.

I must emphasize once again that for this "bounced" lighting, the light must be directed obliquely towards the ceiling. If you allow the light to come down vertically, your model's eyes may possibly appear like sunken hollows, rather reminiscent of the morning after the night before – although it is true that even the demurest damsel pencils black rings around her eyes to suggest a dissolute life. The model should not be too close to the light-source. The light, directed obliquely upwards and sending down its reflected beams in a correspondingly desirable direction, should illuminate the model as brightly as possible.

We constantly come across recommendations for bounced lighting with flash which are not strictly applicable in every case. For

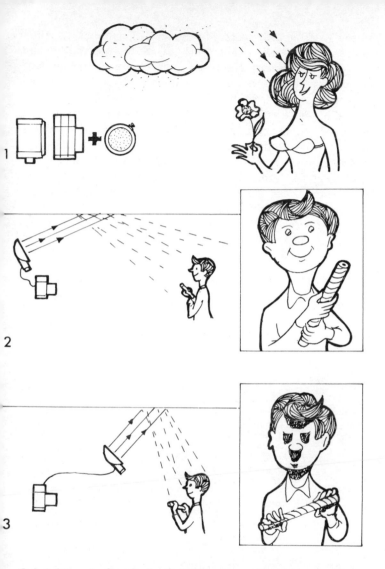

Soft lighting. 1. Standard soft lighting is provided by overcast daylight. With colour film, a pale pink filter may be necessary to avoid a bluish tinge. 2. Bounced flash indoors also provides soft almost shadowless lighting. 3. Flash bounced at too steep an angle leads to top light shadows.

years I have been giving a rule-of-thumb for flashbulbs, which in this case are better than electronic flash, and this has shown itself to be valid. I would like therefore to repeat it here: in medium-size and moderately light rooms – ordinary living-rooms, that is, the guide-number quoted for flashbulbs must be divided by 7. In very small and very light rooms, modern white-tiled kitchens and bathrooms, for example, the figure should be divided by 5. This little bit of simple arithmetic gives us the aperture number to use. But if you are using an electronic flash outfit, you must, according to the type used, open the stop from between half to one degree wider. The very weak electronic flash given by many of the popular small units is insufficient to give bounced lighting, unless, of course, you use a more sensitive film.

Indirect light tones down the harsh lines which age is wont to

EFFECT OF DIFFERENT LIGHTING METHODS

Shadows produced	Light-source	Description of light	Suitability for portraits
No shadow or only light shading	Vast light areas (sky, illuminated white surfaces)	Soft, diffused or scattered	Very good standard lighting
Shadows with blurred light edges, but black centres	Medium sized light areas (small illuminated spot on reflecting surface). Lights in front of which a large sheet of white paper is placed near the model	Soft, diffused or scattered	Only suitable for portraits if used in conjunction with supplementary fill-in light source
Dark shadows with sharply defined outlines	Light source with smallest possible illuminating surface, or more distant bigger lights	Hard or directional	Very good for special portrait effects, but not as standard lighting
Lightened shadows with sharply defined outlines	Light source as above. Also reflecting surfaces or supplementary lights	Hard but brightened	Another established standard lighting

trace on the surface of the human face but the wrinkles are most effectively removed if the light comes mainly from the front. Indirect light is also suitable for use as supplementary lighting. The shadows, which spring up like mushrooms in a meadow when direct supplementary lighting is used, cannot occur with bounced lighting.

As descriptions of light as being "hard" or "soft", "directional" or "scattered", and also the kinds of shadow cast by various kinds of light, give rise to a great deal of confusion, a tabular summary might help you to put the whole matter into perspective. In the following sections we shall deal with the lighting effects produced by the various arrangements of light-sources. It must always be borne in mind that very different effects are obtained according to whether hard, hard but brightened, or soft lighting is used.

Uses of direct frontal lighting

If the light shines from the direction of the camera straight on to the model, it is known as front or frontal light. Cameras with built-in flash or with the flash head attached to the camera give this kind of lighting and, when the flash is extremely small, the light is thoroughly hard. I cannot pretend that this sort of light is to be recommended for portraits, if it is the one and only light used. But accompanied by supplementary lighting – daylight, for example – it produces quite pleasant lighting effects. You need not therefore despair if your camera produces only front flash lighting.

You will find some relevant hints on page 140. A table on page 168 gives you information about exposure times and distances for outdoor flash.

One thing that supplementary front lighting does is to banish wrinkles from the face completely. But even better than hard light a soft front light acts as photographic cosmetic. With its help, creases vanish so entirely that any reasonably well preserved 40-year-old looks like a teenager.

Try illuminating a white wall, for example, or a sheet of cardboard immediately behind the camera with a halogen lamp. The soft-

ened frontal light then hits the model full in the face. We must be clear however about one thing. The anti-wrinkle lighting is obtained at the cost of modelling and fleshiness. If we add further supplementary lamps for indirect lighting – by reflection from the walls for example – our model's physical proportions will not be so severely slimmed, while the facial landscape will be to some extent smoothed out and rejuvenated.

Front and side top-lighting

Even though soft light is the most modern and most widely-used form of portrait lighting, it may well be that you are sick of it. What can be done about it? I should like to mention first of all one method which might be recommended as being the standard portrait lighting of an easy conscience. I mean what is known as "side top light".

Let us assume you want to take someone's portrait in half-profile. At your first attempt you place your source of light at an angle of about 45 degrees to the direction in which the camera is pointing. The light therefore shines obliquely. You now also raise the light until the direction of its beams also diverges at an angle of approximately 45 degrees from the vision-axis of the camera. You don't, of course, need a goniometer to calculate the position of the camera. It is not so much a question of the latest refinement in lighting technique, as of observing the most effective lighting for the model. Now as soon as you raise the light, the shadow sinks and vanishes from the field of vision. One essential prerequisite for this usually welcome effect is that the model should not be placed too close to a light background.

You will be doubtful about one thing: should you have the light falling from left or right? Direct the light-source from the side towards which your model's head is turned. The "smaller" half of the face, as it is called, the one of which less is seen in the picture, must be brightly lit. (In this case use the hard direct light from a single source, and then place this by a process of trial and error until part of the "bigger" half of the face appears to be roughly equal to the "smaller" half.)

In many cases, the "bigger" half, the one turned towards the cam-

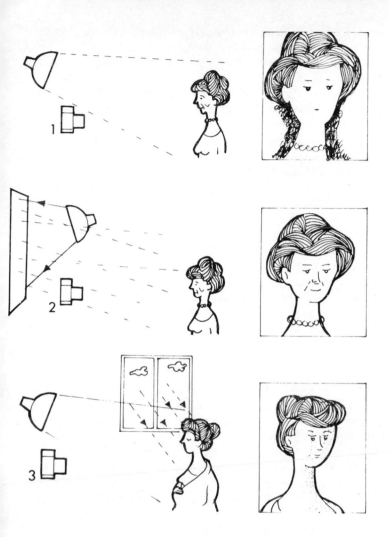

Frontal lighting. 1. A lamp at the camera position produces flat lighting and hard shadows close to the model. 2. Bouncing the light from a large surface reduces the shadows but still gives rather uninteresting lighting. 3. Window light as the main light plus a lamp to lighten the shadows gives pleasant modelling.

117

era, will be illuminated. In the corresponding pictures, the person will usually have one fat cheek.

In other cases, the light falling from above will correct any really puffy cheeks. A fat-faced person photographed full-face must therefore be lit from a front light source at about half height. This will leave the over-luxuriant cheeks quite literally in the shade. All these lighting suggestions apply equally to daylight, photoflood and flash. But whereas, when necessary, we can allow the flash to shine into our model's eyes, this will not do with continuous light sources. After all, it is not very agreeable to make a young woman or a child blink into the camera. The consequence is that in most portraits for which no indirect lighting has been used, the eyes are somewhat shaded. Sometimes even, they appear as dark hollows. This is especially so with portraits when the sun or photo light is above the victim's head. Portrait photography when the sun is high in the sky is best avoided. In any case, the shadow must always be brigtened sufficiently for the eyes to be visible. Otherwise the picture is not worthy to be called a portrait.

On a sunny day out of doors a sunlit wall, a large light area of sand, or a white handkerchief can be used to reflect light on to the eyes and other shady parts of the face. Brightening with flash must also be considered. When the sun is screened by cloud, the shadows are agreeably light and even. A model lit by a filament lamp can also be brightened, either by a reflecting surface or by a second source of light. Indoors, reflection from walls can also be exploited. For this the light source should be as far away as possible from the model.

Once the eye problem has been solved, the question of light intensity depends on the subject of the photograph. Any deeply furrowed character face can bear deep shadow. (He can even screw up his eyes in direct lighting, making supplementary lighting superfluous.) On the other hand, the angelic countenance of a young girl demands powerful shadow brightening.

Side light and spot light

Side lighting is generally taken to mean lighting from well round to one side of the subject, say between 70 and 90 degrees to the

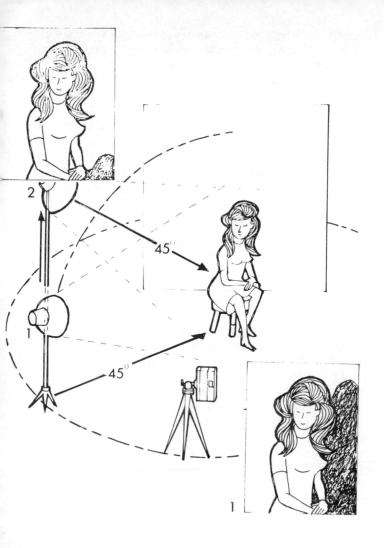

Side top lighting. 1. When the light is at 45 degrees to the camera axis but low down, a harsh shadow may be thrown on the background beside the model. 2. Raise the light to a 45 degree downward angle and the shadow is lowered.

lens axis. Such lighting emphasizes the surface structure of the skin and is therefore used chiefly for profile pictures of more elderly people.

Side lighting is usually hard and directional and is often provided by a spot light.

Whereas diffused frontal lighting shrouds creases like a veil, the beam of the spot-light exaggerates them. The fleshiness of the head and body are also emphasized. This happens more especially when some supplementary fill-in lighting is added from other light-sources or from a more powerful reflection from walls and ceiling. The modelling and the sensual physical appeal are also emphasized when spots are used for supplementary lighting. Should the shadows from the light-beam not be relieved, however, the model will be swallowed up in darkness. Only a few spots of light will remain to give some semblance of life to the picture. In a photograph of this kind much remains, quite literally, in the dark; the shape of face and figure are quite indistinct.

However, despite its lack of clearness, this kind of dramatic lighting can be effective. It suits more especially people of a contentious and complicated character.

To what extent the subject is recognizable or indistinguishable depends on the exact position of the light source. A beam of light from behind creates a border of light round the model.

The background too can play an important part. If it is dark, one can hardly make out the shape of the body. But as we illuminate it more or less brightly, the outlines of the subject gradually emerge, until the brightly lit and shaded areas develop into a clearly recognizable human form.

Back lighting

One of the most delightful kinds of lighting is back light. In this procedure a direct-beam light source with a limited surface area – sun, flash or halogen lamp – illumines the side of the model that is turned away from the camera. The background remains almost entirely dark. It can only become relatively light when the sky itself is used directly as background. The model itself then remains dark, but an edging of light springs up around it. What is more,

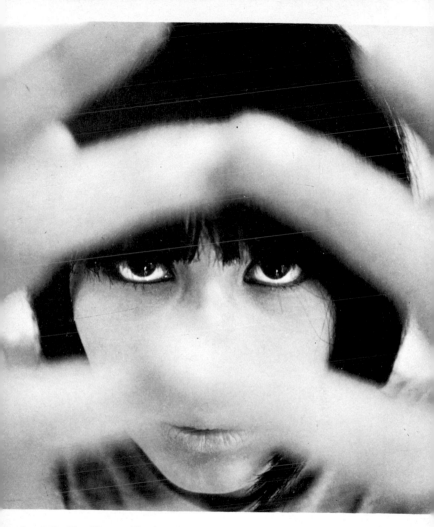

A portrait with a difference. Shot from about 60cm with a 35mm lens and the hands placed together in front of the face quite close to the lens. Lighting was indirect from a 1000-watt halogen lamp.

Opposite: The pictures on the left were taken from about 1.6m and present a normal effect. The right-hand pictures illustrate the distorting effect of too close a viewpoint.

Page 121: The black hair and dark tones of dress and background give prominence to the face and eyes, lit by a 1000-watt halogen lamp reflected from a sheet of white cardboard behind the camera.

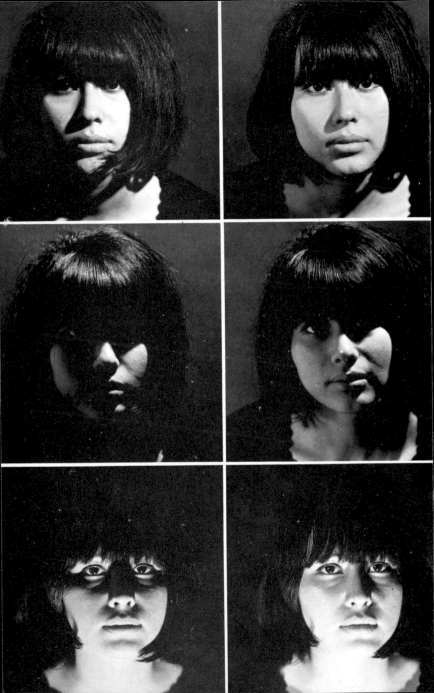

The effect of lighting. The pictures on the far left use single directional light source. The next row have the same lighting plus fill-in from the front. On the right, from top to bottom, the effect of directional front, side and back lighting. The backlit shot was overexposed to make the face recognisable.

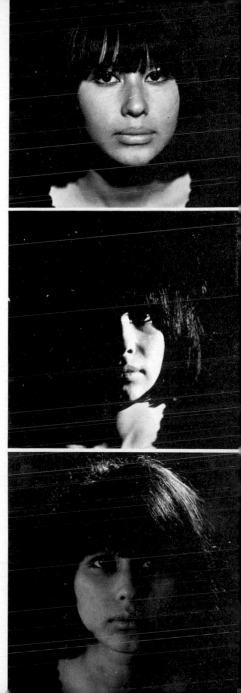

This series of pictures demonstrates the difference in expression brought about by the position of the head and the direction in which the eyes are turned.

Opposite: This graphic effect was created by making a big enlargement on extra-hard paper from a very small image.

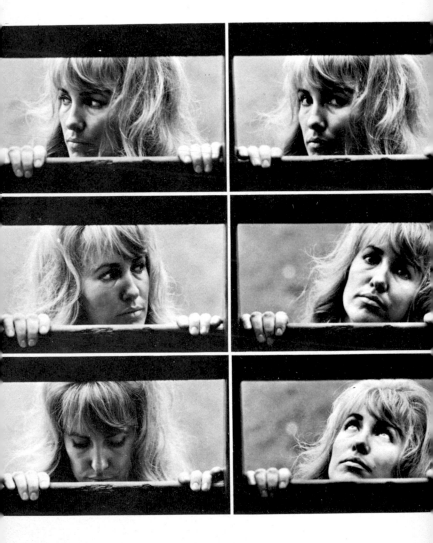

The effect of spotlight distance. When the light is placed very close to the face, strong contrast is evident. When the light is moved farther back, the ceiling and walls act more efficiently as reflectors and throw light back into the model's face.

translucent objects such as hair, materials or flowers are radiant with light.

Contrasty subjects on transparency film must have a short exposure, while negative film must be more adequately exposed. This can be taken as a general rule for against-the-light photos. There are exceptions, however. A profile photo, even on negative film, should be given a short exposure. The edging of light round the head brings out the contour clearly enough. But in a full-face photo the head would appear merely as a luminous wreath, a bright, egg-shaped or pear-shaped object. This would really not be enough. In the open or indoors, fortunately, scattered shafts of light, reflected from floor and walls, dart about everywhere. These throw light on to the face. This is already noticeable if we open the diaphragm by two or three stops.

If we want to be very thorough, we measure the exposure time by the darkened face. The background will then be greatly overexposed, of course, as will be too the translucent hair, which is, we hope, nice and long. This mane, totally devoured in places by the light, comes out completely white. This too can be most attractive, especially if your model's hairdresser has given her hair a Titian tint. With indoor portraits we must not overdo the halo of light, but the face can be quite considerably brightened. In order to increase the intensity of the light reflected from walls and ceiling, the light-source must be placed as far back as possible three or four metres if feasible behind the sitter. In this case there is no need for much, or any overexposure, a detail for which your diapositive film will be grateful.

I am especially fond of briefly-exposed black-and-white backlight photos for another reason; they create interesting graphical effects. Ask your photographic dealer to make you an extra-hard enlargement of a photo of this kind. You will then have an attractive white line running round the head and the body on a black ground.

If you use a corresponding transparency and have it enlarged, you will get, on a white surface, a black contour line which looks as though it had been painted on with a brush.

When making the photograph, be careful to see that the edging of light, which should be as unbroken as possible, surrounds the whole head. To ensure this, you can hide the source of light di-

rectly behind the head. In this case the light border is very thin. Side-back lighting directed against the profile will paint a considerably broader band.

If you place two lamps as back-lights on either side of the model, the result is pincer-lighting. This method, once very common, is quite unsuitable for normal portraits, but is all the more fitting for our graphical experiments. With pincer-lighting we can make even full-face photos, very hard black on white and white on black. If you experience any difficulties about getting sharp black and white contrast, you will find some information on the subject in the section on graphic photography (page 154).

Silhouettes

Silhouette lighting should also be described as indirect, or soft back-lighting. We need, in fact, a large light-emitting or -reflecting surface behind our model. This may be a light shining through translucent paper – one can buy rolls of grease-proof paper for the purpose. You fill a door-panel with it and place your model on one side, straight in front of it, and on the other side, at some distance, the light. I often used to fix a sheet of transparent paper to the ceiling with drawing-pins, and just let it roll down. I could not manage with a door-panel alone, because I wanted to make a full-length silhouette, not merely of the head of the model.

My model had to sit on a table-top in front of this transparent screen, while I squatted on my haunches and took the picture from below. For one thing I wanted to make a decorative picture of the figure. On the other hand, in practice I could only prevent the feet from merging with the table-top by holding the camera at the same level or lower than the table surface. I wanted to have a graphic illustration of my full-length model, including her shoes, so as to be able later, on the positive, to cover the ground under the soles of her feet with white paint. Ideally, of course, these full-length silhouettes should be made with a long-focus lens from a greater distance. But, for lack of space, I had to go up too close to the model.

In order to avoid distortion, which would inevitably have arisen

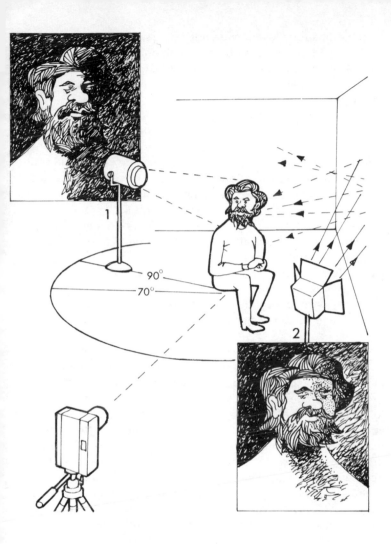

Side light and spot. 1. A spot light at an angle of 70–90 degrees from the camera axis gives hard directional lighting. 2. Diffused lighting from the front or other side can be used to illuminate the shadows to the required extent.

from the close and low camera position, my unfortunate models were obliged to bend their body over to one side, with the head tilted even more obliquely. In point of fact, this rather cumbersome arrangement was successful in circumventing the danger of distortion.

Whereas in normal portraits exaggerated gestures look rather distressing, silhouettes positively ask for way-out postures. I therefore encouraged my models to make these absurd gesticulations. Instead of a translucent surface, of course, the background for a silhouette can also be a light, highly-lit wall. But the lights must be carefully screened from the model, so that no wandering beam of light can spoil the uniformly dark outline.

There is just one thing I must tell you. One can distinguish two different kinds of silhouette, somewhat different from each other: the genuine, and the graphic silhouette.

By the term graphic silhouette I mean that the black outline-shape stands before a "toney" background, such as a light or dark grey sky or a brightly-lit landscape. This is the sort of thing I get if I take someone's photograph in front of a cloud-covered sky.

Colour prints too can show a dark figure in front of some kind of coloured background, and this can be extraordinarily pleasing. In all these cases the camera will be focused on to the background. In processing black-and-white film you must be careful to ensure that the main feature is also sufficiently dark. If what you are chiefly interested in is the graphic element, the subject must be shown completely black against an all-white background. The background can then be slightly overexposed.

You can also greatly overexpose a silhouette in order to obtain a faintly veiled tracing – in transparencies, pleasantly tinged with colour. Pictures of this kind, with their peculiar delicacy, can sometimes be quite fascinating. I have recently seen one or two overexposed silhouettes used as cover-pictures.

However, if silhouette photography were concerned merely with the production of a few pretty graphic effects, it would hardly be worth while spending time on it. But the fact is that if you make a great number of silhouettes, you are giving a tremendously valuable training to your perception of line. You also benefit from this when you devote yourself to normal portrait photography.

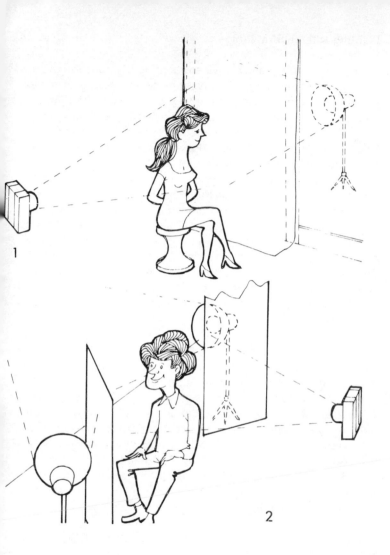

Silhouettes. 1. Cover a doorway with translucent paper. Place the model close to the paper on the camera side and a lamp reasonably distant on the other side. 2. Alternatively, illuminate a light background brilliantly while carefully shading the model from the lamps.

Lighting with several lamps

I will tell you quite plainly why I am treating the question of multiple lighting only marginally in a book on portraiture. In my experience, what has been done with so-called banks of lighting is nonsense. The lamps have been installed at random, and the model has been indiscriminately plastered with their light.

Of course I am not prepared to generalize. There are certainly photographers who are masters of the lighting art. But others have simply drowned their model in torrents of light from many sources, on the principle of the more the merrier. As a result, voices are raised from time to time to declare that no good portraits can be made with floods and flash, and that daylight is an absolute necessity for good pictures. They point to the photographers of the last century, who achieved such wonderful results in their daylight studios. But these old masters were so good, not in spite of the limitations of their equipment, but because of them. The open studio wall faced north, so that even on sunny days the light was always soft.

The fundamental error of the belief that the sun is absolutely necessary for photography is a child of our own day. The scattered light of the studio could only be canalized by means of curtains and reflecting screens. The photographer in his velvet jacket had therefore very few possibilities of light-modelling. But he was completely master of those he did posses. When photographic lamps came in there was at first a decline in artistic skill and craftmanship, as is often the case with technological advances. It is not until the new machinery is fully mastered that the retreat can be halted. The same thing happened when colour photography began gradually to overtake black-and-white pictures. New possibilities offered to us by new techniques often prevent us from seeing the wood for the trees.

Think of the craftsmen in some isolated mountain village. So long as they have only a few paints, which they mix themselves, they produce really artistic work. Once a dealer opens his box of variegated watercolours, the rot sets in. It is not that the villagers' good taste has suffered, but they can no longer cope with the situation. A bank of photographic lamps can only usefully be employed by the man who can take in the whole situation. It is therefore quite

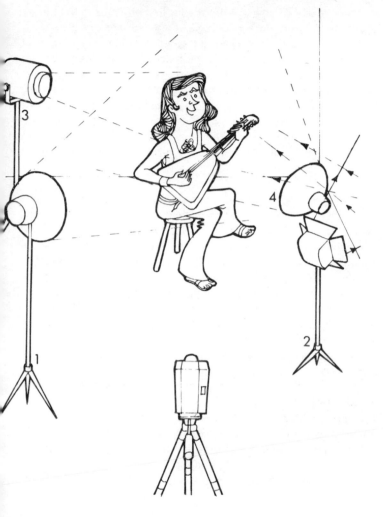

Using several lamps. 1. Main light provides general illumination and modelling. 2. Fill lights can be direct or bounced to give variable shadow relief. 3. Effect light to illuminate hair, clothing, background, provide rim lighting etc.

reasonable when I advise you for your first attempts to get plenty of practical experience in using a single source of light. Apart from that, I would merely admit some supplementary indirect lighting, which can sometimes be helpful and scarcely ever be harmful. Indirect fill-in lighting from a second source of light is also advocated in flash technique. As we cannot in this case control the effect of the lighting, we must find surer methods of lighting installation. But enough of that. I realize that my Cassandra wailings are echoing unheeded round the room. Let me therefore try to describe briefly and in general terms the practical basis of lighting with several lamps.

1 *Main light.* Your strongest light-source, either because it radiates light intensely itself, or because it is placed near the model, forms the main light. It must *by itself* provide satisfactory and characteristic lighting for the model. Anything else that may be used to supplement this lighting plays only a secondary role.

2 *Silhouettes.* Make sure of your model's outline by lighting the background brightly. Even if in your final photograph the background is to remain dark, it pays to study the outlines. This advice is of course superfluous if you are going to make a picture of one section only of the face.

3 *Fill-in light.* Use the softest light possible. The best light for the purpose is indirect light reflected from the walls of the room. The main light should be 1½ to 2 f-numbers greater than the subsidiary light.

4 *Supplementary light.* This is not necessary in every case. If, however, you wish to give an extra glint to dark material or black hair, you must illuminate it from a special light-source. It may also be necessary to use back-lighting in order to make dark hair or dark material stand out from the background.

I should like to supplement the last point by saying that earlier photographers were dead against either pure white or dead-black patches in the photograph. Every part of the picture had to be faultlessly detailed. Today, taste has altered considerably. We accept whiter than white, and especially jet-black places, provided they heighten the picture's graphic effect. Even in enlarging, I tend occasionally to allow the in-between tones, the greys,

Available light. This often means dim light and a fast film is generally necessary. Even if the grain becomes prominent, it is often in keeping with the subject.

to be replaced by pure white and pure black.

Let me also insist once more on the very elegant method of dealing with black hair and material against a dark-grey background (that is, dark-coloured or faintly lit). This is another way of detaching the model from the background.

Available light

The term means just what it says. More particularly, it applies to the following light conditions:

1 Daylight out of doors: weak light from the sky on a dull day, possibly shaded by a screening wall, or else, twilight.

2 Out of doors at night: the usual street-lighting, traffic lights, lighted windows, as well as camp-fires, torchlight and lanterns.

3 Indoors: daylight entering through windows or other openings, and the light from ordinary electric lamps, oil-lamps, candles and open fires.

4 In the theatre: ordinary stage-lighting.

For an available-light shot the photographer uses no extra lamps or other devices, which would, of course, add to the total lighting, but radically alter the characteristic atmosphere. Genuine snapshots – or at any rate, those prepared with great lightness of touch – usually impress by their lively and natural charm, and often by their unusual atmosphere. But they must be made with rapid and ultra-rapid film. The very common fear of using a film in the 650–800 ASA range, on account of possible graininess, is quite unfounded. The grain is only clearly visible in big enlargements. Even then it becomes obtrusive only if the enlargement is made on hard paper. And there is one other thing: I am not going to ride the big-grain hobby-horse, which has been carefully groomed for far too long, but it is a fact that a subject *can* make a deep impression if it is printed extremely hard and greatly enlarged into the bargain, so that the grain structure becomes an integral part of the picture. Certain pictures *may* be more effective when treated in this way, but are not necessarily so. It depends on the subject.

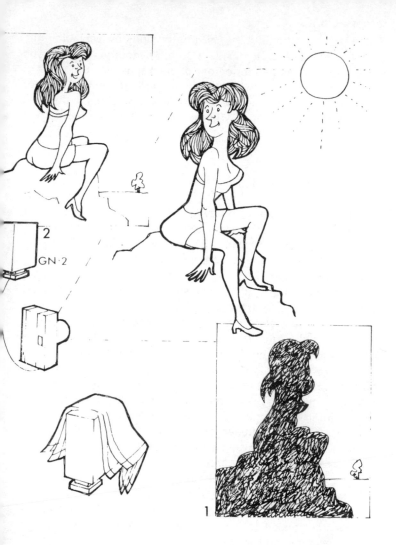

Fill-in flash. 1. Shooting against the light gives either a silhouette effect or a burnt-out background. 2. Fill-in flash from the camera position lightens the shadows. Exposure calculated on a doubled guide number basis is generally accurate. If the shooting distance is then too great, try covering the flash with a handkerchief instead.

There is no question but that for photographs by available light a fast lens (say *f*4 or faster) is a great advantage. Such a lens opens up possibilities for colour photography with the camera held in your hands at twilight or in the dark. But with a simpler camera you need not be afraid of making snapshots in doubtful light conditions, provided you limit yourself for the moment to black-and-white photography.

Fill-in flash in daylight

Frontal flash brightening in daylight is not to be underrated for black-and-white film. If the sun is shining, the flash-gun fixed to the camera, or built-in flash, can brighten the shadows. If, on the other hand, the sky is overcast, flash can take over the role of main lighting, while the daylight is demoted to the rank of secondary brightening light. The splashes of artificial sunlight, falling on to the face from the front, tone down troublesome wrinkles so drastically as to make them disappear altogether.

If you have colour film in your camera, flash must take over the same job. All the effects that have been described, and especially the shadow brightening that bridges the gaps between contrasting areas, are even more important for colour material. In addition to all this, flash brightening can bring about a decided improvement in the rendering of colour values.

In slides, however, diffused daylight, which is so agreeable for portraits, may give the skin a frosty blue tinge. A thick cloudcover is really not so dangerous.

Pictures taken in the shade, under a blue sky, or made in the blue-cast midday hours of high summer, will give markedly pleasanter colours if they are mixed with a shot of flashlight. (Another aid is a light pink filter.) Blue flashbulbs provide a somewhat warmer brightening than electronic flash.

It requires no complicated calculations, fortunately, to decide the amount of flash required. This does not depend on the film speed, but on weather conditions. We must start out from the assumption that the stop setting has to be regulated by the intensity of the daylight. A high-speed film which normally would allow a flash to be used from a fair distance must have its speed curtailed

by the use of a relatively small stop. In those circumstances, the range of the flash cannot be so great. You will find on page 168 a table with some rules-of-thumb for determining the range of various sources of flash.

A few
Facts
about Colour

So far, we have spared only a passing glance or two for the practical aspects of colour photography. Although most of what we have said about black-and-white photography applies equally to colour, there are one or two additional tips I can give you about making colour portraits.

With black-and-white film you naturally use the ordinary negative material and then have prints made on paper. In colour you have to make the agonizing choice between transparencies and negative films. It is true that transparencies are particularly interesting because they allow you to project your pictures life-size, or larger than life, on to a screen. On the other hand, with paper prints you have the great advantage of being able to slip them into your wallet, stand them on your desk or hang them on the walls of your room.

Negative colour film for prints

We will look first of all at the negative film which, like its black-and-white counterpart, is designed to make paper prints. Slide film will be considered a little later. (Slides can also be made from negative films, but they cannot compete in brightness with original transparencies.) The colour rendering of negative film is not so reliable as in slides. The final tone of the picture, whether it is more or less reddish, yellowish or bluish, depends in the final analysis on the taste of the laboratory worker or on the adjustment of the automatic developer. The final colour is not determined until the paper print is processed. However, there is no need to fear that your boyfriend will be turned blue, or that your girl-friend will be given a purple face, although this would be technically possible. The filtering process is so tuned as to produce a fresh, healthy complexion.

So nothing disagreeable can happen, except perhaps if your beloved is particularly proud of her snow-white skin and avoids a healthy out-of-doors tan as she would the plague. But here I would point out that absolute colour fidelity is rarely desired. I recently submitted to the judgment of a large number of people a series of variously filtered colour photographs. One of the pictures was processed so as to be genuinely true to life. All the per-

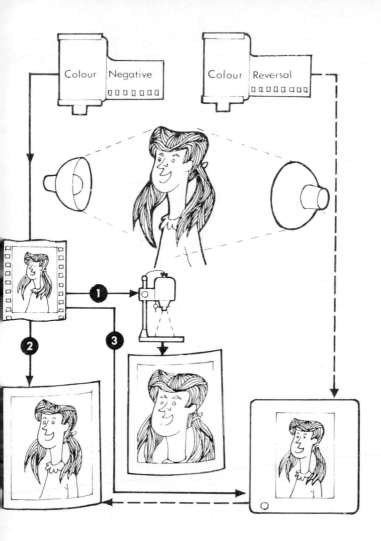

Colour films. A colour negative can be placed in an enlarger (1) to give either a colour or a black and white print (2). Sectional enlargements (3) are possible. It can also be printed on film to give a transparency. Colour reversal film provides a colour slide on the film exposed in the camera. You can have prints made on direct reversal material or via an internegative.

sons taking part in this opinion poll, including the model herself, plumped for the picture which did not come within miles of reality, being grossly distorted to a dark-brown tone – and, what is more, this photo was judged to have reached the height of naturalness.

A photographer once went so far as to recommend that negative portraits should be made with a photoflood as chief light, but that the shadows should be brightened by a white, cold light-source. In this way, the well-lit parts of the face can be filtered into a deep leathery-brown. At the same time the shadows, under the influence of the cool fill-in light, remain more or less neutral.

It is a cast-iron, but little-known rule of colour photography that the person who looks at a picture is quite unconcerned about the most faithful colour reproduction possible, but finds the most flattering and most impressive photo quite naturally the best.

The average person's colour perception is very acute but his colour memory is deplorable. If you enlarge your colour photographs yourself and this is a very nice hobby – you will naturally have it in your power to achieve accurate resemblance at will. From transparencies one can also make paper prints whose colour approximates very closely to the original. But this pre-supposes one thing: that the original slides do not show any great contrasts.

If you have it in mind to make transparencies which will serve ultimately for making prints, you must be careful when taking the photograph that neither the difference in brightness between the colours of the subject, nor the variations in lighting are too great. Either the shadows must be lightened with flash, or provision must be made beforehand for soft lighting, indirectly from photofloods, for example, or from a cloudy sky. Somewhat more brilliant transparencies can give good colour prints if you choose to go the roundabout way of making an intermediate negative; but even in this case, the lighting contrast should be kept as small as possible.

I do not belong to that anxious band of photographers who are meticulous about the exposure, whether of slide or negative film, in order to ensure that the lighting contrast is no greater than 1 : 4. This means the main light must not be more than four times the power of the fill-in light. If I am making transparencies for projec-

tion, I am ready to accept a considerably greater contrast, even though the shadows may not look quite "natural". This does not worry me in the least. If, however, the end-product is to be paper prints, the contrast must be kept as low as possible, as if one were trying to get something in the nature of a silhouette-effect. What is certain, I repeat, is that, in this respect, reversal transparency film makes more critical demands than negative film.

It is well known that transparencies differ from one manufacturer to another. And yet it has surprised me to discover how very similar the results achieved by good-quality films are in reality. I have experimented with different makes of colour film, but apart from slight differences in the bluish tinge of the "whites", the results were found to be virtually identical.

Colour balance of clothes and surroundings

The ten rules given below are intended to offer you a helping hand at the start of your journey into the exciting territory of colour portraiture. They lay no claim to universality. Tastes and feelings vary in course of time, just like trends in fashion. Advice which may be in advance of photographic style today may appear reactionary tomorrow.

To dispel any misunderstanding, I will make it clear that the rules concern a host of different aspects of colour portraiture, and cannot therefore, by their very nature, all be applied at one and the same time.

1 Confine yourself, at the beginning especially, to a few colours, and keep clothing and background colours as sober as possible. Even the blue sky can "prettify" a picture's character. A uniformly grey sky is much less dangerous in this respect.

2 Background colours of a cooler tone than those of skin and clothing – blue-green, blue or green, for example – give an impression of depth and space. This makes the model emerge three-dimensionally from the background. If the background colours are warm – red or yellow, for example – the model seems as though stuck to it, especially if the clothing includes cooler tones.

3 Face and hands will be clear and pleasing in a colour portrait if clothes and background match each other in colour and brightness. A girl wearing a white bonnet and coat, for example, with a background of cloudy white sky, looks interesting because her brown complexion stands out clearly from the rest. You will also get a good colour effect from, say, a blue blouse in front of a blue sky, or a green suit with a green meadow as background. Cool colours contrast with the fresh skin-tones.

4 Choose a small enough section so that the background largely disappears. It is a good idea to repeat the colour of the dress below the chin and above the head of the model. A sea-green tie, for example, would match what is seen of a sea-green hat. Conversely, brightly coloured hair – it may be Titian-red – would be repeated near the lower edge of the picture by a reddish fur or fur collar. (Long, fiery locks are best combed out so that they hide the neck-opening of the dress. The face then gleams palely from the surrounding red mane).

5 There can be no doubt that neutral tones are suitable for background colours. Warm colour, such as yellow, orange and red, can be pleasing in a portrait, provided they have the same intensity and brightness in clothing and background.

6 Luminous, preferably monotone clothing, – not too bright – may have, as an alternative to a background of similar colour, a dark or even black one. In such cases the face emerges radiant from the total surroundings.

7 If the clothes have red in them, the lips should if possible be of the same colour.

8 The larger the surface of neutral colours – white, grey and especially black – the brighter must be the dots of colour in background and clothing. A dark-haired girl, for example, wearing a black dress in front of a black or dark grey background, will look well with a coral necklace, coral clips and coral-coloured lipstick. Even quite differently coloured bright spots will come out well in the picture if they are set off by a large area of black.

9 People with dark skins, such as Africans or ski-instructors, can bear strong, dark colours in costume and background more easily than fair-skinned types. The white of the teeth and eye gleams brightly from the picture if neither clothing nor background are substantially lighter than the colour of the skin.

10 Finally, I will let you into the secret of a little trick which can be used when necessary to make the colour of clothes and surroundings merge with one another. Simply photograph a face through a screen of green or yellowish-green foliage. The leaves must be so close to the lens that they appear in the picture as big, soft blobs of colour, partly obscuring the subject. You may only get one section of the face more or less clear, shining through the green or yellow "nebula"

I hope that these suggestions, which leave you plenty of elbow-room in the field of colour portraiture, will enable you to pick out one or two useful tips that will come in handy for one purpose or another. Remember that it is not only with indoor pictures by artificial light that the colour values of your subject can be influenced. Various types of background can be placed behind a model, even out of doors. In practice, it is of the greatest importance to realize that the blue, sunny sky will appear as a neutral white, provided it is used as back-light. Even over-gaudy colours in some article of clothing can be toned down or neutralized by counter-lighting with the help of heavy shadow. And I cannot repeat too often that *my rules help you to make better portraits – but the best photos of all demand two things: that you know the rules and that you also know when to break them quite ruthlessly.*

Some
Special Types
of Portrait

Only too often you will come across the occasion when some-body feels it necessary that you should take their portrait in front of a monument, beauty spot or other noteworthy feature. Miles of stereotyped snaps showing minute, insignificant figures in front of gigantic fortresses, churches, castles and temples wind their way after every holiday period through the developing ma-chines of the processing laboratories.

Portrait plus location

It must be admitted that to combine a large-scale head picture with a historical monument is no easy matter. I have myself strug-gled in vain to solve the problem by all kinds of fruitless methods. Nowadays I go about it sometimes in this way. I put the head in the right or left-hand bottom corner of the picture, and place Notre Dame, or the Parthenon or what have you, in the remaining empty space. But the important thing about it is that I make it a rule to take the building more or less – generally more rather than less – out of focus. I don't quite understand how it comes about, but the fact remains that a portrait of this kind, showing, for ex-ample, the towers of Westminster Abbey looming hazily out of the background, gives you far more of the London atmosphere than if I had shown all the architectural features in clear detail.

There is really no point in making the face and the monument equally sharp, if only because there is then no sense of space, something which in most pictures of this kind is highly desirable. For another thing, the person looking at the picture cannot tell to which part of it he is supposed to pay the greater attention. When I really want to bring out in detail all the beauty of the view, I prefer to make another portrait, a little out of focus, in front of a needle-sharp background.

By the way, one rather neat solution of the places-of-interest ho-liday problem is supplied by mirror-images of historic buildings, and so on. When the reflection appears on the surface of a lake or a puddle, you photograph it at the same time as the head of your model taken from above. There is little difficulty about a panoramic view with a figure in the foreground. In this case the whole scene can be sharply defined, because the space between

the person and the landscape is bound to give the picture a certain contrast in colour and brightness. The model has warm colour tones, while the mountains are blue. For the same reason, you can put a sharp black silhouette in front of an equally well-defined background of landscape or architecture. This is, as it happens, a most effective method of showing people and scenery together on one photo. The dark outline emphasizes the spaciousness of the landscape.

As an alternative to figures in a landscape as a theme for a holiday snap, a small lantern in the garden of a château can be more impressive than a complete wing of the building. This unmonumental representation of an edifice, by restricting it to a small detail "places" a holiday portrait as well as anything could.

Children in front of the camera

What we want above all is natural expression. From this point of view the under-sevens present no problem as models. We have only to see that they are engaged in some exciting game: they will be so engrossed in it that they will not notice the camera that is pointed at them, or even the flash. Flash is naturally considerably better for children's pictures than photofloods, which are too bright for their sensitive eyes and may even provoke tears.

Older children are often very shy in front of the camera. With them you will only succeed by using a genuine snapshot technique. Nevertheless, if some lively competitive game is in progress, even they pay no attention to the camera.

The best opportunities for portraits of children of all ages are provided by holiday at the seaside.

An important point. For children's head portraits you can go up with your camera as close as 1 metre, or with profile pictures, even nearer, without fear of unwelcome distortion.

Passport photographs

Passport photographs have an unenviable reputation. The fault lies partly in official regulations. Regulations never do photog-

raphy much good. But you should be familiar with the rules. After all, you might very well need to make a passport picture in a hurry. Generally full-face portraits are required, without headgear or earrings. People who normally wear glasses should keep them on. Bearded men have often had trouble at frontiers. Having inadvertently deformed this token of their manliness, they removed it altogether. And in doing so, they quite forget that they cannot shave their passport photo at the same time. For some reason, women seem to be less affected by incidents of this kind. The dearest wish of the United Kingdom authorities is that the size of the passport picture should not be less than 2 x 1½ in and not more than 2½ x 2 in.

Whether you wish your likeness to be "passported" in colour or in simple black and white, is left entirely to your own choice. The enlarging paper used for black-and-white photos must be white and on single-weight, glossy, but unglazed paper.

Graphic photography

I have already alluded on several occasions to my fondness for graphic photography. So far, it has been a question of the following procedures for obtaining worth-while graphic portraits:

1 Silhouettes.
2 Hard back-lighting, which creates an edging of light.
3 A grain-structure picture from an over-blown-up hard negative.

If photographs of this kind are to be turned into graphic form, all their unwanted greys must be expunged. Pure black and pure white tones only must remain.

In addition to the methods already mentioned for obtaining extreme hardness one must consider the overexposed soft-lighting portrait. A head in front of a light background has to be indirectly lit, as evenly as possible and overexposed by two stops. With enlarging on very hard paper, the tones of skin and background are merged into a whitish area. The pupils of the eyes, the eyebrows, nostrils and hair appear completely black.

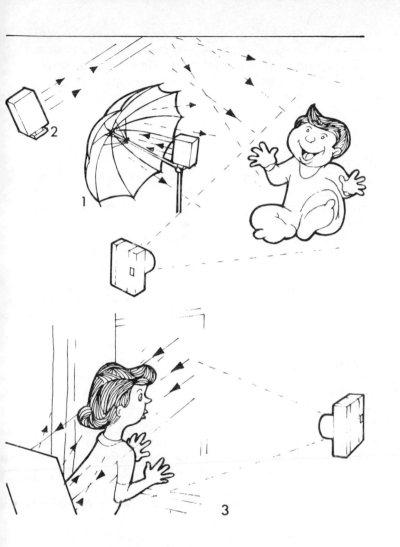

Children indoors. 1. Soft lighting for very young children can be provided by umbrella flash. 2. Bouncing the flash from ceiling or walls gives a similar effect. 3. Window lighting is ideal but a reflector may be needed on the shadow side.

If neither you nor the processing laboratory succeed in getting perfect contrast by simple enlarging on extra-hard-paper, you can photograph the picture itself once more and, if necessary, repeat the process again and again ... until you get the required result. I make things much easier for myself by simply putting photos of this kind through a copying machine. Nowadays every office has this bit of equipment.

You must of course use a method which really does give you satisfactory whites and blacks.

If you take your photographs from the word go on document film, you will get a clear-cut graphic photo after your first enlarging operation. I always use 125 ASA film and expose it as for about 25 ASA.

All graphic photography experiments can be carried out as negative white on black printing. For this you must have a transparency made from your negative. It is often sufficient, however, to take your photograph in the first place on reversal film. You then make a black-and-white enlargement of it, just as you would for a negative.

Mirror pictures

The professional photographer has a hard time of it with his customers who, despite all he can do, find that their photos do not look like them. In hopeless cases, the only way out is by means of a trick. The photographs are enlarged laterally reversed. This satisfies the customer's long-felt yearning. He feels that the picture is really like him at last. He only knows himself, of course, by his mirror-image.

But the man who does not have to earn his bread by photography, but just takes photos for the fun of it, has no need to debase a picture's documentary character by manipulations of this kind. A better way out of the difficulty is to take a photo in a mirror, and this will be clearly recognizable. In this way you will satisfy your model without the necessity of cheating.

You must be careful about focusing. If you were to focus according to the distance between the camera and the surface of the looking-glass, you would be focusing too close. What counts is

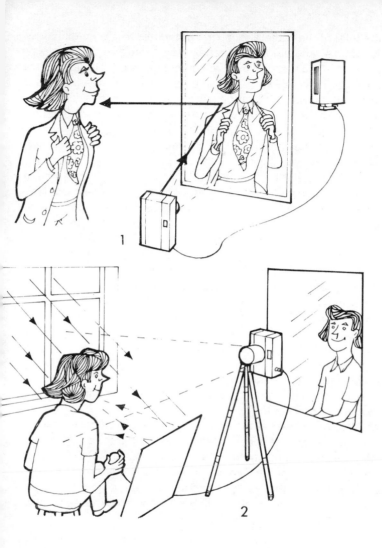

Self portraits. 1. The focusing distance is from camera to subject via the mirror. The lighting must be directed at the subject. 2. With a long cable or pneumatic release, you can shoot directly, using the mirror only to check the pose.

the total of the camera to mirror and mirror to model distances. An optical rangefinder or a reflex viewfinder give you the exact focusing distance, provided you do not focus on the frame of the mirror but on the mirror-image. It often happens that the frame does not lie within the range of definition, but this need not be a drawback. It goes without saying that you point the camera somewhat obliquely at your model in the mirror. If you stood squarely in front of the glass, you would take your own photograph. There are two practicable methods for lighting mirror-portraits. The source of light – usually flash – can be placed to one side of, above, or below the mirror. In this way you illuminate the face, which is then brightly mirrored in the glass. In so far as the model is taken in by the camera, he appears, possibly reduced, as if surrounded by an edging of back-lighting. What we have in fact in front of us is strong back-lighting; we must therefore be careful to see that no unwanted light falls on to the lens. You can exclude this danger completely by adopting the second, simpler, and at the same time better lighting suggestion. This is to allow a light-source connected with, or built into the camera to shine bang into the looking-glass. The latter reflects the light on to the model, which is therefore brilliantly illuminated. You then have an equally brightly lit image in the mirror. In this lighting arrangement, naturally, the same distance determines the flash exposure and the focusing. Total distance from light-source to mirror and from mirror to model.

Most mirror-portraits are self-portraits, and most self-portraits are mirror-portraits. It goes without saying that for a self-portrait only the first lighting method can be considered. If the flash itself comes into the picture, there will be ugly irradiations.

Another point is that mirror-portraits make it possible, with a single light-source, to obtain lighting effects which would otherwise only be possible with two lights.

Caricatures

Most of the hints I have given you so far have been on how to make your model look prettier or younger in the photograph. Who would want to look even uglier in a picture than he really is?

I always try out horrifying pictures on myself in the first place. A distorted portrait can make the person concerned – in both meanings of the word – extremely angry, unless, of course, he happens to have an unusually generous sense of humour. It would be a wise precaution for anyone about to tie himself to another person "till death do us part" to apply the character test of a caricature portrait to the intended partner.

Try it at first with footlights. You will find that light shining full on the face from a source situated steeply below gives the most angelic countenance a diabolical grimace. The reason for this is that in the natural order of things light never arrives from this direction, unless we are standing on our head or whirling through space. Light does shine upwards from camp-fires, open grates and sometimes from candles and oil-lamps. Nevertheless, our face seems constructed on the whole for lighting from above. The eyes are protected to some extent from the sun by their projecting brows.

Television and the cinema use and abuse low lighting in order to regale their audiences with evil spirits, bloodthirsty pirates, madmen and murderers.

Eerie shadows cast by low-placed lights spring up threateningly on to the background. And yet only the hard lighting from the footlights contorts faces into monstrous masks. Lighting from below, when the shadows are brightened, can have a quite particular effect, and has the special capacity of imparting a worldly sensuality to women who, by chance, might be lacking in this quality.

We must, however, be clear about one thing: footlights, brightened or not, in every case make the face look broader. The lower parts of the face – the chin and the cheeks – are exaggerated, the forehead remains in shadow and may appear rather undeveloped.

Used alone, or in addition to low lighting, a caricatural effect is given by perspective distortion. You either use a normal lens with a supplementary lens, or, even better, a wide-angle lens, and go as close to the face as possible. (If you put a supplementary lens of one diopter on to your camera lens and focus at 1.5 m on the distance scale, you can go up to within 50 cm or about 20 in). At such close range, the nose will swell up into a bulb and the ears

will shrivel into minute rudimentary appendages. Take your victim from above, and his face will become pear-shaped.

A low camera position on the other hand gives your model the chin of Neanderthal man.

Facial peculiarities can be clearly, in fact, too clearly delineated – more clearly than the person concerned would like. Politicians and other people in public life are occasionally photographed in this style with a super-wide-angle lens just for a lark. This may be a harmless joke.

At other times, however, low-minded individuals have been known to ruin the career of a political opponent by publicity of this kind. And it is hard for the victim to do anything about it. The face of the unfortunate individual is merely distorted – so badly distorted that the man's character is liable to suffer the same distortion in the minds of the public.

We cannot allow ourselves nowadays the luxury of turning away our eyes from the possibilities and impossibilities of this kind of political assassination.

A dash of the erotic

In tackling the subject of glamour photographs, I realize that at best I am entering upon the fringe of portraiture. Pin-up photos are incapable of reflecting to the full a human beings' personality – nor do they attempt to do so. The individual's sex-appeal has to be exploited to the full – short of incurring the displeasure of the public and of the powers that be. It follows that for the photographer, the publisher and the consumer – as the viewer of these pictures is unkindly known – the model's type is important, but not her personality.

It is true that photographs of people, and even portraits, are not only concerned with personality. In the Middle Ages artists confined themselves to the idealized pictures of saints. It was not until the 15th century that portraiture gradually underwent an important development. Our own day seems to be returning to a fondness for unpersonalized ideal figures in the representation of human beings. But at all events, it is no longer a question of saints. It would be regrettable if this were a sign that our society

was more interested in types – the typical working man, the typical member of the ruling class, or mannequin or good companion – than in personality. Communities in which the individual is of no account tend to become sclerotic and to disintegrate.

These gloomy forebodings no doubt lead you to believe that I have something against people who take pin-up pictures or who pose for them. The very opposite is the case. I shall come later to a few random suggestions about pictures of this kind, which I would very much like you to try. Let me give my reasons.

First of all, I think that both photographer and model should look a little more closely at the mechanics of pin-ups, and the best way of doing so is by practical experience in making pictures. It is good for *him* to realize that *she* must be properly put into the picture, so as to appear – well, we're a bit shy about it – just as attractive in a photograph as the girl on the cover. And it is good for *her* to discover that she has something worth showing. It enhances her self-respect, and self-respect enhances in its turn the attractiveness of her appearance, which is recorded by a pin-up picture, which . . . and so on and so forth.

However, let us not make too much of this. But I must say just one thing. When we examine ourselves closely, we find that we are not always and everywhere the same person. There are several personalities within us, many of them not anxious to be confronted with each other. A human being is not *only* what the cover-picture would have us believe; she (or he) is *also* a sexually motivated creature. We can be glad and thankful that the sensual side of our personality sometimes takes over. So sexy pictures have their place with others in a collection of photographs that can be made of a girl. (If we concern ourselves solely with feminine models, it is because the woman's personality is more strongly marked by sensuality than the man's.)

I should like to mention marginally that a sitting for a pin-up portrait can liberate people who are awkward in this respect from their inhibitions, enabling them from then on to assent to the sensuous side of their nature.

It is high time I came to the practical side. You might try this to begin with. For a head-and-shoulders portrait, choose a low camera position to emphasize the figure. The upper part of the model's body is in profile. In order to draw attention to the outlines,

the hands should be placed on the hips or behind the back, and the head turned towards the camera or thrown back. An oblique glance is directed downwards into the lens. This arrangement is also especially well designed to conceal any aesthetic failings, such as an over-fleshy nose or too pointed chin. According to some pin-up experts, a pout or a half-open mouth heightens the erotic effect.

The lighting must be soft and from the front; this smooths out any wrinkles. For indoor photos there should be indirect front lighting, and in cloudy weather out of doors, frontal flash to brighten the shadows. Admittedly these recommendations seem somewhat frivolous – but then pin-up photos have something frivolous about them – and in any case, who can deny that a little triviality now and then may have its charm?

Although this section is getting long anyway, which, on such a charming subject, is not surprising, I will say one or two words about photography of the nude. A great deal has already been written about the subject, partly for, and partly against. I have the impression that of every 1000 words that have been written 1001 are lies.

Writers are especially fond of comments like this: "One has the earnest intention of de-sensualizing the nude as such. One must adopt the fundamental attitude which results in restoring the beauty of the human body to its own natural aesthetic place in the picture, thereby eliminating all intrusive eroticism".

I should just like to ask one question: If someone wants to make a non-erotic picture, why does he photograph a naked woman? The main reason for nude photography is surely that it captures the model's sensuous charm and enhances it by aesthetic modelling. In this connection, many people are fond of pointing to the artistic forms of classical Greek statues. Agreed: they are works of art. But the Venus of Milo and the caryatids of the Erechtheion and the Winged Victory of Samothrace surely have a certain erotic appeal? *I* have not the slightest doubt about it. It may be that some over-aesthetic observers are in no position to feel it – it is another world to them. But the sensuous charm is there and the ancient Greek artists intended it to be so. The whole dubious attitude to the nude springs from the existence of a twilight zone between I dare and I dare not.

In Central Europe the nude has an honorable tradition. At the end of the Middle Ages portraiture included the representation of the unclothed human body. Lucas Cranach the younger sold nude paintings wholesale to his aristocratic clients.

It was not, of course, just a matter of "women with nothing on", – that would have been immoral. The preference was for edifying subjects from the Bible, such as a scantily clad Salome with the head of John the Baptist. The moral story, non-biblical, it is true, of Lucretia, who killed herself after being dishonoured by Sextus Tarquinius, was a favourite theme. Judith, carrying the severed head of Holofernes, also belongs to the same class of painting. One single moral and, what is more, religious picture combining sex and crime is by way of being a masterpiece.

In my opinion, photography of the nude has nothing to do with morals – and has nothing necessarily immoral about it. That being so, there is no need for the nude model to turn away her head. The averted gaze, as the embodiment of an uneasy conscience, contributed to give photography of the nude a suggestion of illegitimacy. Nor am I of the opinion that nude photographs should only be made in the open air, amidst cornflowers and gurgling brooks, hey nonny nonny! As a second step you might choose to make overexposed irradiated silhouettes. And with this piece of advice I must leave you to your own devices, for the experiences I have accumulated in this field are for the most part still before me.

In search of personality: an experiment

The numerous rules in this book are intended to help you to make good portraits. Yet many of your own photos will certainly turn out to be especially exciting for the very reason that you have had the courage to ignore the instructions given. What is more important, however, than rules to be followed or broken is that the person taking the portrait should be interested in his model. You, as an amateur photographer, will naturally have friends as models, possibly some with whom you carry on a mild flirtation. By using a suitable camera position and suitable lighting, you must bring out as clearly as possible those characteristic features which you

find most interesting. Of course, certain marks of character are inscribed on the face, but they are sometimes so delicately delineated that they may go unrecognized. But there is a way of bringing out a person's concealed characteristics by the use of a little subterfuge.

The method is as follows. You take a frontal view portrait. Your model's eyes must look straight into the camera, and the lighting must be as soft as possible. From the negative, you make one normal enlargement, and another, laterally reversed. You then take a pair of scissors and cut the two pictures down the middle. The cut must divide the face exactly in half. Now you join one normal and one reversed half together. These two new portraits are absolutely symmetrical. One shows only the left halves of the face, and one only the right halves. Because only an infinitesimal minority of people have both sides of the face as like as two peas, the characteristic facial signs, which are almost unrecognizable in a normal portrait, stand out clearly in the cut-out montage. If you have difficulties with a model because you are not too sure which characteristic you should bring out most clearly, this experiment may help you to discover one characteristic trait or another.

Check-list for portraits

Finally, and as a sort of summary of all that has gone before, here is a check list of matters that need your attention before you irrevocably commit your subject to the film.

Before pressing the button, make sure you have taken into account all the important points for portraiture. The following list will make your job easier, especially for your first attempts.

1 *Distance between camera and subject:*
Too short? Too great? Head-and-shoulder? Head only? Section of face? Three-quarter length?
2 *Format:*
Upright? Horizontal?
3 *Finder:*
Has the difference between the viewfinder image and the real image been allowed for? (Parallax)

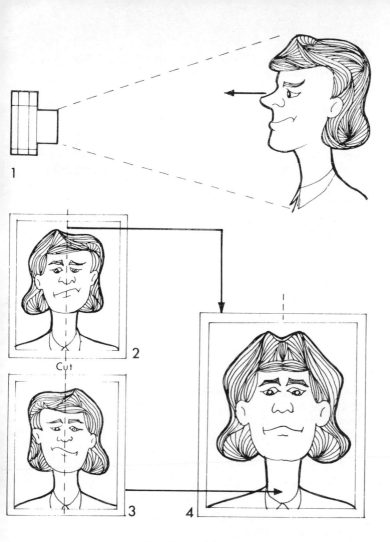

Finding the hidden character. 1. Shoot full face with eyes looking into camera. 2. Make two prints, one normal, one laterally reversed and cut them down the centre. 3. Join the opposite halves of the prints.

4 *Background:*

Is it obtrusively sharp? Sufficiently out of focus? Fussy? A uniform surface?

5 *Brightness of the face:*

Is the skin-tone striking? Has it its own grey or colour-tone? Must it be corrected by a filter? By lighting?

6 *Clothing:*

Are there no colours to distract attention from the face? Does the brightness of the colours harmonize with the background?

7 *Definition:*

Have you focused exactly on the eyes?

8 *Camera position:*

At eye-level? High? Low?

9 *Head posture:*

Full-face? Profile? Quarter, half, three-quarter profile?

10 *Eyes:*

Looking straight into the camera? To one side? Upwards? Downwards?

11 *Hands:*

Picture without hands? Both hands in the picture? Hands "cut off"? A good arrangement? Are the hands occupied?

12 *Posture:*

Eyes, hands, body in opposition? Legs and arms ditto?

13 *Make-up:*

Powder needed for shiny skin? Lipstick too light? Too dark? Eye-shadow? Skin-blemishes concealed?

14 *Lighting:*

Problem-free soft light (overcast sky or reflected flash lighting)? Hard, overhead light? Heavy shadows? Eyes as black hollows? Brightening needed? Indirect brightening? Brightening with flash out of doors? "Cosmetic" indirect front lighting?

15 *Direction of lighting:*

Top lighting? Side lighting? Top side lighting? Spotlight? Back lighting? Footlighting? Front lighting?

16 *Colour of light:*

Warm daylight? Excessively blue light? Brightening with flash? Light pink filter?

17 *Expression:*

Distraction by conversation? Shock? Head turned round?

EFFECT OF FILTERS ON BLACK-AND-WHITE AND COLOUR FILM

Filter Colour	Type of film	Filter factor (longer exposure or larger stop)	Effect
Yellow, medium	Black and white	1½–2	Blue comes out darker (sky), red lighter (lips, skin blemishes).
Orange	Black and white	3–4	Same tendency as yellow filter, but considerably stronger. Green becomes darker.
Red	Black and white	4–6	Even much darker than with orange. Faces very pale
Green	Black and white	2½–3	The red of lips, but also of skin blemishes and tan exaggerated. Blue becomes rather darker, green lighter.
Light Blue	Black and white	1–1½	Yellow and orange appear darker. Like the green filter, the blue disc is sometimes used for black and white portraits with photoflood lighting.
Skylight filter	Reversal colour	1	Suppression of blue cast in shade or on overcast days. Improvement of skin-tone rendering.
Salmon pink colouring	Reversal colour	1–1½	As for skylight filter, but more effective.
Conversion filter (blue)	Reversal colour	3–4	For daylight colour film in artificial light.
Conversion filter (orange)		1½	For artificial light colour film in daylight.

RANGE OF FLASH OUT OF DOORS

The following table gives the range of a few types of flash-bulb for brightening shadows in daylight. The exposure is set at $1/25$ to $1/30$ sec assuming that X-synchronisation is used. The aperture will be as required for that exposure time – as if no flash were used.

Type of flash	Range in sunshine	Range with overcast sky
AG 1 B, PF 1 B, XM 1 B	Up to approx, 2 m or 6 ft	Up to approx, 7 m or 23 ft
PF 5, XM 5	Barely up to 3 m or 10 ft	Up to approx, 10 m or 33 ft

As the brightness of the daylight depends on the whims of the weather, the above estimates can be taken only as rough guides.

FIELD OF LENSES AT VARIOUS DISTANCES

Size	Focal length (mm)	At distance of 1 m (cm)	At distance of 1.5 m (cm)	At distance of 2 m (cm)
24 × 36 mm	35	65.8 × 98.7	100.8 × 151.2	134. × 201.
	40	57.6 × 86.4	87.6 × 131.4	117.6 × 176.4
	45	50.9 × 76,3	77.5 × 116.3	104.2 × 156.9
	50	45.6 × 68.4	69.6 × 104.4	93.6 × 140.4
	90	24 × 36	37.4 × 56.2	50.9 × 76.3
	135	15 × 23	24.2 × 36.4	33.3 × 49.9
6 × 6 cm	75	77.5 × 77.5	108.3 × 108.3	144.4 × 144,4
	80	72.7 × 72.7	100.9 × 100.9	126.8 × 126.8
	150	31 × 31	51.3 × 51.3	70.1 × 70.1
18 × 24 mm	25	68.8 × 103.24	108.2 × 162.3	142.2 × 213.3
	30	58.1 × 87.2	88,2 × 132.3	98.3 × 147.4
28 × 28 mm	38	70.8 × 70.8	107.5 × 107.5	145.6 × 145.6
	40	67.2 × 67,2	102.2 × 102.2	137,2 × 137.2

A Few
Terms
Explained

ASA: The measure of film sensitivity. A high ASA number indicates a high degree of sensitivity. A film with an ASA figure double that of another has twice the speed; with half the ASA figure it has half the speed. The medium speed film is about 100–125 ASA.

Aperture (diaphragm, stop): Essentially the stop is a hole which can be varied in size to permit more or less light to pass through the lens. The individual points at which the stop is set are provided with numbers.
The scale of aperture numbers (*f*-numbers) may read like this:

$$2.8 - 4 - 5.6 - 8 - 11 - 16 - 22 - 32$$

The smaller the number the greater the aperture. With the widest stop – in the example we have given, 2.8 – the whole lens is uncovered. At any point, the next smaller number allows double the amount of light to reach the film. Exposure times and stop numbers are correlated. If I reduce the exposure time by one step, I must open the diaphragm by one stop if I wish to keep the same exposure. So if my exposure meter recommends *f*8 at $^1/_{125}$, I also have the choice of: $^1/_{60}$ at *f*11, $^1/_{30}$ at *f*16, $^1/_{15}$ at *f*22 or, in the other direction, $^1/_{250}$ at *f*5,6, $^1/_{500}$ at *f*4 and so on.
The smaller the aperture is made, the greater is the depth of field. Pictures in which only a very shallow zone is sharply defined are very often considerably more effective. For this reason I prefer a wide-open stop combined with the shortest possible exposure.

Automatic camera: A special type of camera with a built-in exposure-meter. The measuring apparatus controls the aperture and shutter-speed setting and ensures automatically when you press the shutter release that the necessary amount of light – neither too much nor too little – gets on to the film. With flash, normally, the automatic exposure is disconnected and the aperture-setting operated by hand.
Semi-automatic cameras have a built-in meter but you set aperture and shutter speed by reference to meter needles or marks visible in the viewfinder or elsewhere on the camera. Generally, when a pointer is opposite a mark, you have set the correct level of exposure.

Close-up lens: Supplementary lens for attachment to camera lens to enable close-ups to be made at less than the minimum focusing distance of the camera lens.

Contrast: "Hard-working" films render light tones even lighter and dark tones darker than they are in reality. They increase contrast. Films of low sensitivity are usually contrastier than those of high sensitivity. Transparency films are more brilliant, and therefore more contrasty than negative films.

Depth of field: The depth of the area which is sharply defined by the camera depends on the one hand on its distance from the object, and on the other, on the size of the diaphragm aperture. The farther away from the camera with any given lens, and the smaller the image on the film, the greater is the portion of it which is clearly shown. In addition, the depth of field increases considerably with the smallness of the aperture.

Electronic flash unit: A complete flash unit with discharge tube, which provides virtually any number of flashes. Electronic flash units are powered by various types of battery, according to model, and can often be operated from domestic electricity supplies.

Exposure: The opening of the shutter gives free passage to the beams of light and allows them to penetrate to the film, that is, they expose it.
Shutter speed and aperture are interrelated so that the film receives its correct amount of light. Automatic cameras ensure this relationship automatically. With other cameras shutter speed and diaphragm aperture must be operated manually. The automatic setting is easier, but setting by hand has the advantage of familiarizing the photographer more thoroughly with photographic practice. With overexposure, negatives become too dark, and transparencies too light. Underexposure, negatives too light and transparencies too dark.

Exposure meters: Devices for measuring the exposure. The light falling on to a light-sensitive surface in the meter either generates an electric current or introduces more or less resistance to a cur-

rent generated by a battery. The electric power can be used, for example, to move a needle over the exposure-scale, or else – in the case of automatic cameras – to control the exposure time.

Exposure time: Many simple cameras have only one exposure time, somewhere in the region of $1/30$ or $1/50$ sec. The exposure scale for more sophisticated cameras is something of this nature: 1 sec, $1/2$ sec, $1/4$ sec, $1/8$ sec, $1/15$ sec, $1/30$ sec, $1/60$ sec, $1/125$ sec, $1/250$ sec, $1/500$ sec. Some also include $1/1000$ sec, or even faster and a few have a greater range of slow speeds. Together with the stop, the length of exposure determines the admission of light. It can also affect the sharpness of the image because long exposure times lead to blurring of moving subjects and to blur due to movement of the camera. Generally the camera should be firmly supported on a tripod or other stand for exposures longer than $1/30$ sec. For the utmost sharpness, the camera should be supported and a cable release used for *any* exposure.

Extension cable: An extension cable plugged into the camera between the flash-unit and camera flash socket allows the flash to be detached and fired at a distance from the camera.

Finder: The finder, or viewfinder, shows the photographer the exact or approximate area of the subject which will be seen in the picture, according to the camera design. The non-reflex camera viewfinder gives a slightly different view from that of the lens – a noticeably different view at close range. The reflex viewfinder gives exactly the same view as the lens but generally shows a fraction less than actually appears on the film.

Fixed focus: Some inexpensive cameras have small lenses of moderate maximum aperture preset to a focus which, by making use of the depth of field, gives reasonably sharp images of objects from about 5–7 ft. from the camera to the far distance. No focusing mechanism is provided and such lenses are therefore known as fixed focus. Any moderately short-focus lens can be similarly set to a smallish aperture (say *f*11) and a mid-distance (say 25–30 ft) to act similarly.

Flashbulbs: Small bulbs, today mostly lacquered blue, are used in flash holders, which can be built into the camera, These bulbs give a comparatively bright flash. Four flashbulbs with four reflectors inserted in the four sides of a cube are marketed as flashcubes. Fitted to cameras with special holders they provide rapid sequence shooting, because advancing the film also turns the cube and brings another bulb into position.

Focusing (Distance setting): A lens theoretically forms a sharp image only at the plane on which it is focused. In fact there is a certain amount of depth of field which allows as sharp an image to be obtained over a reasonable distance. The distance of the principal subject from the camera can be estimated, measured with a tape-measure, shown by an optical rangefinder, or seen on the focusing screen. Many cameras have rangefinders built in to the camera and coupled with the focusing mechanism, but separate rangefinders can also be obtained. The viewfinder of a mirror-reflex camera, of course, enables you to keep an accurate control over sharpness and focusing, but even reflexes usually have rangefinder spots in the centre of the screen.

Graininess: The image on a film is made up of minute grains of silver. The more sensitive the film the coarser is its grain. Formerly, black-and-white films of about 40–50 ASA were preferred on account of the fines of their grain. Manufacturing techniques have now overtaken this state of affairs. Today even films of around 400 ASA have a reasonable grain structure.

Guide number: For any given flashbulb or flash unit used in conjunction with a film of given sensitivity, one is sometimes given what is known as a guide number. This, divided by the distance between light and object, gives you the stop number. For example, a flashbulb is used with a film whose guide number is 28. For distance of 5 m you get 28/5 = 5.6. If on the other hand you divide the guide number by the f-number, you obtain the distance between light and object. Instead of guide numbers, tables for stop-number/distance can be used. These are usually printed on the back of the packet of flashbulbs.

Long-focus lens: A lens which brings the object nearer, and so gives a bigger image on the film. Like all interchangeable lenses, long-focus lenses can be fitted only to types of camera from which the lens is designed to be removed.

M contact (M synchronization): Cameras with between lens shutters often have M-synchronization for flashbulbs. The advantage of this contact is that flashbulbs can be used with high shutter speeds, which is only possible with focal plane shutters if a special type of (rather expensive) flashbulb is used.

Negative film: As its name indicates, negative film produces a negative picture, from which as a general rule prints are made. The large majority of black-and-white films are negative films. Colour negative films can give both colour and black-and-white prints.

Objective: A combination of lenses in the camera projecting the image. Objectives (often referred to simply as lenses) differ in their maximum light transmission (speed) and in their focal length not to mention, of course, price and quality. The speed of the lens is indicated by its smallest *f*-number, i. e. *f*1.4 is faster than *f*2.8. The focal length is generally expressed in millimetres and there is a normal standard focal length for each format, i. e. about 50 mm for 24 × 36 mm and about 75 mm for 6 × 6 cm. Longer and shorter focal length lenses to vary the angle of view and therefore the size of the image on the film can be fitted to interchangeable lens cameras.

Portrait lens: A type of long-focus lens with a fairly long focal length, which is often used for portraits. The focal length is usually between 1½ times to twice as long as that of the normal lens.

Reflex camera: A distinction must be made between twin-lens and single-lens reflex cameras. The twin-lens type is provided with a second lens having the same focal length as the taking lens. The finder lens, as it called, has the task of projecting the picture on to a groundglass screen via a fixed mirror. This enables you to judge the focusing distance, the approximate picture

174

area and the effectiveness of the picture. In the single-lens camera, the picture projected by the taking lens is reflected from a movable mirror on to the screen. On the release of the shutter, the mirror is automatically moved out of the light path. Single-lens reflex cameras show no parallax error.

Sharpness: The sharpness of a photo depends in the first place on correct focusing (distance setting). Then the shutter speed must be fast enough for the photographer to hold the camera without shaking it. When the camera is held in the hands, it is advisable to use an exposure of $1/125$ sec. or faster. If the photographer's arms can be supported, exposures of $1/60$ sec, $1/30$ or even slower may be possible if absolute sharpness is not essential. These longer exposures, however, generally necessitate a tripod or other stable support for the camera. If the model itself is moving, of course, the exposure must be relatively short, even if a tripod is used.

Shutter: The camera mechanism which opens for an exposure, allowing the light to reach the film. The blade shutter – often placed near the diaphragm, between the lenses of the objective – consists of blades which swing outwards to form a more or less circular hole. Focal plane shutters can be seen as two rubber-cloth or metal curtains which pass in front of the film. In doing so, they leave open a slit through which the light travels on to the film.

Stand: In general a tripod with telescopic legs for giving the camera firm support.

Transparency film: Also known as reversal film or film for slides. The exposed film is generally sent to a processing laboratory, where it is processed into slide form. Home processing of some reversal films is also possible. The positive image appears on the film used in the camera.

Wide-angle lens: A lens which includes more of the object, which therefore appears smaller in the picture. Like long-focus lenses,

wide-angle lenses can be used only in cameras designed to take interchangeable lenses.

X contact (X synchronization): All cameras have built-in X contact, primarily for use with electronic flash. If a camera, as is usually the case nowadays, has one contact only, this will be an X contact. At shutter-speeds of $1/30$ sec. and longer, all flashbulbs and speed-lights can easily be activated by an X contact. On some later shutters, however, particularly the vertically moving focal plane types, X-synchronization with electronic flash is possible at up to $1/100$ sec.

Index